WHAT IS CONSERVATION?

Edited by: PETER N. MILLER
Published by: BARD GRADUATE CENTER

WHAT IS CONSERVATION?

COPYRIGHT © 2023 BARD GRADUATE CENTER. All rights reserved. This book may not be reproduced in whole or in part, in any form (beyond that copying permitted in Sections 107 and 108 of the US Copyright Law and except by reviewers for the public press), without written permission from the publishers. Authors retain copyrights to individual pieces.

Series: BGCX
Series Editor: ANDREW KIRCHER
Copy Editor: DAVID SASSIAN
Art Direction and Design: KATIE HODGE
Display Typeface: Akira Expanded by TYPOLOGIC
Body Typeface: Freight Text by JOSHUA DARDEN
Photography by DA PING LUO and BRUCE M. WHITE
Published by BARD GRADUATE CENTER
Printed by GHP Media
Distributed by UNIVERSITY OF CHICAGO PRESS

ISBN: 978-1-941792-37-7
Library of Congress Control Number: 2023934911

BARD GRADUATE CENTER
38 West 86th Street
New York, NY 10024
bgc.bard.edu

ABOUT THE PUBLICATION

BGCX publications are designed to extend the learning period around time-based programming so that it may continue after the events themselves have ended. Taking the spontaneous alchemy of conversation, performance, and hands-on engagement as their starting points, these experimental publishing projects provide space for continued reflection and research in a form that is particularly inclusive of artists.

This book is an unconventional introduction to the topic of conservation, understood in its broadest sense and with an eye toward its greatest significance. The conversations threaded together in *What is Conservation?* took place over three nights in spring 2022 and accompanied *Conserving Active Matter*, an exhibition at the Bard Graduate Center Gallery New York, and the book and web publications of the same name. The photographs in this volume are drawn from that exhibition. We are grateful to the participants—Dani S. Bassett, Peter Cole, Jeffrey Gibson, Campbell McGrath, Sendhil Mullainathan, Stanley Nelson, Lauren Redniss, Beth Shapiro, David Spergel, Marla Spivak, Ubaldo Vitali, and Emily Wilson—for their time and generous engagement.

What is Conservation? was supported by an X-Grant from the John D. and Catherine T. MacArthur Foundation's Fellows Program. We are grateful to the foundation for its interest and support and, in particular, to Krista Pospisil for her care and attention to this project. The events at BGC were created and managed by Laura Minsky and Jen Ha as part of our Research Programming. This book was produced with the assistance of Daniel Seungchurl Lee, director of publishing, Katherine Atkins, managing editor, and Alexis Mucha, associate director for sales, marketing, and rights for publications. To make this book even more useful, we have appended a list of titles referred to in passing by the participants in the conversations.

Cover: *Conserving Active Matter* exhibition image by Da Ping Luo.

PETER N. MILLER The occasion for this conversation is the current exhibition at Bard Graduate Center (BGC) titled *Conserving Active Matter*. The show uses the challenge of new types of active materials, and also new notions of how we humans activate inanimate objects, as a way of asking about the meaning and future of conservation. It's the culminating act of a 10-year project at BGC, Cultures of Conservation, funded by the Andrew W. Mellon Foundation. That project was about showing the different ways in which conservation integrates with the humanistic study of the material past, and also about the history of conservation as a field of object study.

One of the things we've learned from the project is that, from the perspective of activity, what we think of as "conservation" turns out to be a very parochial 19th- to 20th-century Euro-American thing that was then globalized. By which I mean that the field of practice rests upon a set of philosophical perspectives on material constitution, authenticity, change, and the values associated with each of these, that tie it to specific moments in European intellectual history. Conservation in India and Japan, to take two examples we have explored in this same project, looks different, because those underlying philosophical commitments—the histories—are different.

We learned something else from the project, too. We came to see "conservation" doing work in many more places than the studio, workshop, or laboratory. We saw it in collecting, whether by institutions or, even more intriguingly, by individuals in their own lives and homes. We saw it in the mending, tinkering, and "vernacular" repairs we make to our

material culture and surroundings. Of course we saw it as well in the connections to the "historic preservation" of buildings and the "conservation" of wildlife, even though the use of these same words in disparate domains has not, thus far, triggered a reevaluation of their wider importance. And we have found conservation in the elemental structures of our own existence: DNA is an extraordinary vehicle of conservation, now studied intensively by researchers seeking to reconstruct the evolutionary history of many species, not just our own. And memory, which ties together our own individual identities, is perhaps the most self-evident expression of conservation and its urgent necessity. Anyone who has witnessed memory's fraying and unravelling needs no reminder that without conservation we are no longer ourselves.

But without memory we are also not *us*. In the same way that this project is writing conservation into the landscape of individual memory, we can look to the literature on collective memory for help in understanding how conservation works collectively. In the exhibition, the stories of Paikea and his family and of the making of Nora Naranjo-Morse's *Always Becoming* (2007), give us thick descriptions of how conservation and memory intertwine on the social scale. We can, in turn, read conservation and community back into the biographies of objects, in the spirit of Igor Kopytoff's now-classic "The Cultural Biography of Things" (1986).

Once alert to the centrality of *conservation/preservation/ restoration*, we find them in shockingly prominent cultural places. For example, a central text of Italian Renaissance historical work is entitled not Rome *Revived*, nor Rome *Reconstructed*, but Rome *Restored* (Flavio Biondo, *Roma instaurata...*, 1444–46). Thomas Hobbes, in *Leviathan* (1651), located the origin of modern politics in the need for self-preservation: "The final cause and or design of men in the

introduction of that restraint upon themselves in which we see them live in commonwealths is the foresight of their *preservation* and of a more contented life thereby" (italics added). Hobbes's contemporaries Galileo, Newton, and Leibniz also talked about the conservation of force, or momentum, though it was Hermann von Helmholtz whose 1847 "On the Conservation of Force" established the modern scientific standard. And through his impact on the neo-Kantianism that dominated scientific philosophy around the turn of the 20th century, it is Helmholtz who could be said to ground the epistemology of object conservation. Now, none of them—not Biondo, not Hobbes, not Helmholtz—were talking about the conservation of art objects, yet we might not have noticed their shared language, and thus its wide resonances, had we not had our attention first drawn to the issues raised by the conservation of art objects.

To do justice to this range of meanings we have assembled a collective polymath: MacArthur Fellows from the arts, natural and social sciences, and humanities. Asking them to think aloud together seemed the surest, best way of winkling out all the possible realms of nuance in the words

conservation/preservation/restoration.

*But since this is work we want
to do through conversation,*

let's now turn to our panelists.

To begin, could you first say a few words about how you intersect with these terms?

JEFFREY GIBSON

In my early twenties, I did work at the Field Museum in Chicago for a few years as a research assistant on NAGPRA, which is the Native American Graves Protection and Repatriation Act, passed in 1990. And that was a huge learning experience, very life altering, and I feel like I've spent the last 20 years unpacking a lot of things that came up then.

One of those things was about the fetishization of pre-Columbian—but also let's even say just pre-20th-century—material culture of the Indigenous Americas. And when we get to the 20th century, suddenly these objects start coming into the play of the market and are very much undervalued. But in my work, what I try to do is to place them centrally and in the context of other kinds of imagery and objects and materials, to think about and question the role that value plays, when these tell an equally valid story of Native American experience in this country.

The Indian Arts and Crafts Act, also of 1990, was meant to allow only members of federally recognized tribes to create this kind of imagery or use this kind of imagery in their work. And so this kind of authenticity of image use and distribution and production came into question. Things that someone could have purchased, let's say at a gas station on a road trip through the Southwest—something that feels much more iconic in the way that we think about Native American symbolism, this imagery that is an "X"—I try to mix up all of these different symbols, really, of late 19th- and 20th-century Native experience.

So, for me, when I think about these words, I'm thinking about trying to pose the questions that allow for this long-

running conversation about authenticity, tradition, futurity, and past and personal narrative, collective narrative. It's been static in one place for the majority of my lifetime, and I'm trying to think about the questions that reengage it and keep it contemporary, so that it can move on into whatever that next chapter is. That seems to be where I've been focused for some time now, and I imagine will remain for some time into the future.

SENDHIL MULLAINATHAN

When I heard the word *conservation*, I was excited to participate for two reasons. I guess that the second one is much more in my economic wheelhouse. The first one is related to what you mentioned, Peter. It's a funny thing, you write this whole long book, and then it's only five years later when someone says something to you, and you're like, "Oh, that's what I should have said."

So, I have a friend of mine who said, "Oh, my biggest takeaway from your book was that all the problems of scarcity begin during times of abundance." And I was like, "Oh, yes. That is exactly right." The reason you are too busy and have too little time to do "X" now is because when you've had a lot of time you just frittered it away. Scarcity concentrates our minds. Abundance actually is bad exactly because it doesn't engage the mind. When there's abundance, we barely notice there's a state to begin with. We just are. It just is. When there's plenty of time left, there isn't any "time," because there's an infinity of time.

Time is not noticeable. And so, for me, from that perspective, I might almost say that the problems of conservation are coming too late. It's when we have a lot of something that we should be asking ourselves, "Oh my, at what point will we want to be conserving this?" And I feel like that has been true in my life, and as I start to look around the world, it's almost tragically true that we act too late, because the scarcity of things draws attention only once they're scarce, not when they're about to be scarce or, ideally, well before they are about to be scarce.

So that's one thought I would put forward. The other reason I thought your email was so interesting was that I had...I am an economist by background, and I am always on the lookout for what is really missing from the economic model. What is the kind of thing that is a first-order thing that's missing? But obviously economists miss a lot of things, so that's not hard. But what's something that's missing that we're now starting to be able to say something about?

The National Bureau of Economic Research is the place where a bunch of empirical economists publish papers about their work. And there was a paper in July 2021 that really caught my eye. It was on the "circular economy." Now, I don't know if any of you know what this is. I had no clue what this is, and I can guarantee you that almost no economists know what this is. This paper was introducing the concept to economists. It was one of these shocking things where I'm like, "Why have I never thought about this before?" So, as economists we talk about things being produced, things being sold, there's a price, there's an equilibrium. There may be pollution. There's externalities, so that the producer of something doesn't take into account benefits or costs to other people. That's what we talk about.

The "circular economy" just opened my eyes that there's something so obvious, you all will laugh at this and say, "How did you all not know this before or even think about this?" But it's something that from an ecology perspective, it's like a natural point which is, "Okay, you produce, you use. What happens to the stuff you use? Where does it go? Does some of it get reused? And how should you think about an economic system where more stuff is reused? And how should you think about an economic system that breaks iPhones after two years, isn't that bad? What are the incentives to create more durable things? What are the incentives to create more reusable things? How does the system as the whole manage the circular economy of reusability versus the economy of disposability?"

And those questions…I'm not the best-read person in the world, but this is not something I think most economists have ever thought of. And it should shock all of you and shock me to say, "Wow, how have we not considered this?" And think about it, these are the people who are trained in this discipline or the people who go to set policy at the highest level. So, I think there are some massive gaps in our thinking about these words *conservation/preservation/restoration*.

CAMPBELL MCGRATH

It is really fun to be here. I love conversations that cross borders in this way. And, in fact, conversations that remain in poetry-land are almost of no interest to me. But when you start hearing from people across disciplines is when you say, "Oh, that's so interesting." Because we do remain, despite our attempts, I think, a little bit in our silos, not just in academia but just in whatever we are practicing. That's why it's really great to hear this kind of talk.

So, what I do—which is, I use poetry as a tool of historical and cultural investigation, which is not typically, I guess, what poetry is thought of as being for. And I guess it really isn't, maybe, normally for that. I certainly do enjoy writing love poems and haiku and all sorts of things, but particularly my very desires to be a historian, anthropologist, cultural thinker, all just get subsumed, and I don't have to do the hard work of actually figuring things out. I can just turn it all into a poem. Any errors are blamed on somebody else. I try to take stuff out of the world around me and maybe through that word *consciousness* filter it through my own mind. And then my natural desire is to find a way to put it in form as a poem.

LAUREN REDNISS

I write visual nonfiction books. They're not graphic novels, they're not children's books, they're journalism and oral history integrated with artwork. I report the books, I write them, and then I create the artwork. I'm interested in the friction between the writing and the words and the design. That might mean the arrangement of each page and the other physical parts of the book and the endpapers. And, of course, the cover. It's all integral to the book's conception. It's the presence, the physical weight of the object in your hand. I think it's all part of how a reader makes meaning.

I usually create a new font for each project, because I think it's a subtle way to underscore the voice of the book. I'm hoping to create a reading experience that's immersive, even central, even when the subject matter is difficult. A lot of my work deals with science and the environment, climate, extractive industry, and their impact on lives and communities. My most recent book, *Oak Flat*, is about the development of what would be the largest copper mine in North America. The body of copper that would be mined here happens to be located under an Apache sacred site in southeastern Arizona. This is a place that's called in English "Oak Flat." In Apache it's "Bildagoteel." Oak Flat has long been the site of Apache religious ceremonies. It's also where Apache people come to gather foodstuffs and medicinal plants. And the mine would destroy Oak Flat. The book follows two families, an Apache family and a mining family.

What I thought was relevant for our conversation today is that for over 100 years Oak Flat has been part of the Tonto National Forest. So, it's "protected" land, but like all of our now

"national" forests, our national parks, it's land that was taken from Native peoples. So—and it's right in the name, the Tonto National Forest—the government pushed the Tonto Apache onto reservations to create this national forest. So, you have this kind of history of conquest masquerading as conservation, and that history ends up echoed in what's happening with the debate over the mine today, because copper is this material that has been called the metal of the information age. It's crucial to our smartphones, to high-speed internet access—we couldn't be on Zoom without copper—but it's also a crucial element for renewable energy, for solar and wind power.

The politicians and the executives are using environmentalists' rhetoric to argue for this mine, saying, "Well, if we want to pivot from fossil fuels ... we need this mine." So again, you have this kind of conservation rhetoric that's a cover for profiteering. It's classic greenwashing.

STANLEY NELSON

For the last 40 years or so, I've been making documentary films. Many of them are about African American history. And one of the things that we try to do is look at histories that haven't been told, or were mistold, and try to retell them in a very different way. A large part of what we do is let people try to tell their own stories. So, for the last, probably, 25 years of that time I've been making films without narration, with no other voice except, mainly, of people who participated in the events that are being discussed. We dig very deeply into archival material, and archival material includes anything from video or pictures or audio or music—anything that helps us tell the story and can bring people into the past.

One of the things that is fascinating for me about what I've been doing is that it accomplished, it involves, so many different things: the research of the film, the actual shooting of the film, the editing of the film—and we've just really been more closely in touch with getting the film out there and into the world, which is a big deal. And the last film we did, *Attica*, being nominated for the Academy Award, it took it to a whole different and unknown level. Just getting the film out there and publicizing it, and we're just coming off a six-month process of basically all day, every day, publicizing of the film.

So, many times I end up acting as a conservationist, filming people, maybe telling their stories for the first time, and it's really interesting because of the process of editing. But we're using a very small, a tiny part, of the stories of the people that we've interviewed. That's just part of the process of making films.

DANI S. BASSETT

I'm a scientist by training, and the key theme of my work is the investigation of complexity in the world around us. Complex systems are composed of many, many small units that interact with one another in really mysterious ways to produce very massive, large-scale phenomena. These sorts of systems are really difficult to understand and to predict, and they span from the stock market, which, for example, can crash unexpectedly; to the human brain, which can produce consciousness; to sand piles, which can avalanche at any moment. For centuries now, scientists have been slowly making progress in understanding these particular systems by isolating and characterizing the individual units they're composed of. And what we've come to realize over the last several decades is that the units themselves are not really enough to explain the system.

We need some sort of language in which to encode the intricate pattern of interactions between units that makes these massive, large-scale phenomena possible. So everything, from the stock market crashing to the human brain, produces consciousness. Complexity science, which is what I focus on, provides this type of language. It's a mathematical language, it's a conceptual language, it's a theoretical language that embraces the intricate network of pervasive interactions while at the same time distilling the simple rules of function in physical, biological, and social systems.

PETER COLE

My work both as a poet and as a translator is very much about that being in-between, and not just being in-between but being at one and the same time both in and between different cultures. And that includes not just the American–Middle Eastern divide but, within each space, lots of subcultures, especially on the Jerusalem side but also of course on the American side. I have translated extensively from Hebrew and somewhat from Arabic, but I'm also, and especially of late, interested in what we can call that translation that we're all carrying out all the time between different planes of our lives—visual, oral, verbal, musical—those kind of little translations that we're improvising all the time. It's really become the subject of my work, I think in, say, the last 10 years.

I have a new book coming out in fall 2022 called *Draw Me After*, which is a line from the *Song of Songs*. And what I'm interested there really is a kind of relation analogy. Dani just mentioned these complex interrelations between units as being what needs to be mapped, and in a sense I think of myself as trying to do that, mapping verbal matrices. But what that is all about, really…*Song of Songs* is pointing to desire. It's a question of how one preserves ways of sustaining and being sustained. How, literally, that can be carried out in languages of all kinds.

EMILY WILSON

I am a classicist, a literary scholar, a cultural historian, and a literary translator, with an interest in ancient Greek and Roman literature and philosophy and their later receptions. And I suppose that for me the term *reception*, as opposed to *conservation*, might be something we want to have out there in the dialogue. I'm interested in how cultural and literary representations get transformed in later traditions. Rather than preservation, I'm interested in transformation. I'm interested in how, even at what might seem like the earliest stages of a poetic tradition, with the poems of Homer, *The Iliad*, *The Odyssey*, there's already a sense of transformation of a much older mythic tradition.

The Iliad isn't conserving or preserving. This is what we always say about Homer's Trojan War. It's offering a really interesting and distinctive take on the Troy legends that is different and, presumably, unexpected to its earliest audiences. We know there were certain elements in the mythic situation that are excluded from *The Iliad*. It's a weird poem about this very ancient set of myths. So, I'm interested less in conservation and preservation, I would say, in terms of myth and literature, than in how literature can reimagine what might be a very old or ancient trope or story and make it into something new.

I'm interested in ethics and values as represented in literary texts, especially ancient texts, and also in the values and ethics involved in engaging with ancient texts in later periods—texts that come from earlier periods in our own culture. One of the questions that always arises in that regard is "What do we preserve? Who do we preserve? What does it mean? What are

the ethics of preserving words composed by enslaving colonial rapists? And what do we do with that tension between the values that we might hold as readers or interpreters of these texts and the values that might have been dominant in the societies from which they come?"

I'm also, as I said, a translator as well as a literary critic and historian. And in my work as a translator, I'm constantly wrestling with what it means to replicate something, to produce some kind of *equivalence*, which, again, I think is an adjacent term to the trio of terms in our conversation today. I'm constantly thinking about how to create not just semantic equivalences but also sonic, stylistic, or rhythmical kinds of equivalences. I'm also constantly thinking about how difficult, or even impossible, it is to conserve or preserve if I'm moving from one language to a totally different language.

I think the most common assumptions about what a translator should value or prioritize in the process of trying

to "preserve" the essence of a text are often misguided. Students, and also scholars, often think that if you replicate the dictionary definitions of what those words are, then you've preserved something. But you might not have preserved anything that's important. You might not have preserved the style, the mood, the register, the characterization, the energy, the emotions that might be…Almost everything might be missing if you've preserved just what the dictionary says that word means.

I think a translator, maybe, has to start from the position that preservation is impossible. And of course, my Homer, my *Iliad*, my *Odyssey*, are not actually preserving any of the words of the original. So then, what does it mean to be in some way responsible in telling the truth? I tend to think in terms of responsibility and some kind of truth-telling, but also in terms of the choices that are at stake, always, in thinking about "How do I tell some kind of truth, knowing that I can't preserve and knowing, sometimes, that I can't conserve?" Once you know it's impossible, then maybe you can start doing the work.

UBALDO VITALI

I am a silversmith, an art historian, an alchemist, and all the things that are necessary to create something out of metal or clay or whatever. That is the reason why I'm interested in art: it's a changing of matter, a transformation. Living in Rome, being born in Rome, I was subject to certain experiences that, actually…I was very fortunate, because in the sixties, conservation and restoration were trying to assume a new face. The first publication by Cesare Brandi about restoration was a cornerstone of what we think of as restoration today. And it

was great, because I was there. Not because I contributed to anything, but I was able to listen to these people, what they were trying to achieve concerning past items that had changed, in order to preserve the past. It was great. And in Rome, also, we worked—my family, my father, and my grandfather—in different workshops; but we also worked for the *Soprintendenza*, the overseer of all museums, so we were able to restore objects from every age. And each one of those objects gave me a great opportunity to focus on what perhaps conservation, restoration, and preservation really are.

One thing that comes to my mind was an object. There was…Because I also take great pride in restoring religious objects, from Christians or Muslims or Jews. I find it inspiring because they are trying to communicate to a child's level. And I always try to find out what motivated them. For instance, in a certain case, the Jewish object was done by a Christian goldsmith, but yet he's able to absorb what the Jewish man wanted in that object. Those are fascinating things.

But the most fascinating thing is that this object…I believe that every object is a memory, a memory of the artist of the time and so on. But many of these objects are actually a combination of different levels. I remember restoring the relic of the head of Saint John the Baptist, the *mandibula*. And I remember very clearly that the lower part was 13th-century Sienese. And then it goes up and up and up through the centuries. Now, as a conserver, which part do you preserve? Which part do you think is more important?

What I believe is that we try to preserve each one of them, because each one represents a specific memory. For instance, in the 16th century, that object was saved from the sacking of Rome. When the armies of the Holy Roman Empire came down and raped and pillaged into the whole thing, it was stored away, buried, to save it. And then, the next century, it

was brought out and enlarged with different things. So, there it is—like a skyscraper. Each floor represents something. And whenever we think of an object, obviously they are memory palaces, and in these palaces, you have a basement, you have a first floor, second floor…And that's what these things are. The reason why I'm interested in all those others is because we need to know about all of them in order to restore some small part of one of them. We simply cannot be specialists.

BETH SHAPIRO

One of the roles that I play is conservation biologist. I'm interested in specifically using this term *conservation* in a very different way than it's used here, but what I'm most interested in…Well, back up a little bit. The way I got into conservation is the fieldwork that I do looking for ancient DNA. I go out into the Arctic, and I dig up bones of things that used to be alive, and we grind up a little piece and extract the DNA. The history of the evolution of that individual—of its population, its species, its ecosystem—is in that DNA. And so we piece together these DNA sequences, and then we use math, different types of models, to understand how we can pull from that DNA sequence the history of that species's evolution.

The oldest DNA that we can get is around a couple of tens of thousands of years old. There are other examples: we published a paper last January where we got a million-year-old mammoth's DNA, but that's exceptional. Mostly what we've been focusing on is how people, since we emerged as a lineage, have impacted the evolution of everything that's around us. And what's fascinating to me about this, and relevant to this discussion, is that the first impact was that we drove lots of things extinct; and then we, our ancestors, discovered that keeping the family fed didn't necessarily mean that things had to go extinct. We figured out reproductive biology. And we learned that if we left females, we would have individuals next year. And this was the beginning of agriculture and hunting and herding and farming. And then there were so many of us and so many of our domestic species at the turn of the 20th century that we discovered that if we wanted a biodiverse

planet, we would have to take over control of everything. And that is conservation.

In my field, we often think of conservation as leaving things alone. But in fact it's the absolute opposite. We have to go in and manipulate everything. We decide where things get to live, how many individuals get to reproduce, where and what they get to eat, et cetera. And so conservation really is a very hands-on manipulative thing in the natural sciences, even though people mostly have the impression that it isn't.

I'll skip over *preservation* for now, but I wanted to think a little bit about the idea of restoration. Restoration is now this big movement in ecology, but it's problematic, because restoration means that we have to decide what the ideal is. And this, I think, harkens back to what you're saying: "Well, who…who are we to decide?" If we want to restore here, look at your land acknowledgment: Do we restore it to what it was 50 years ago? To what it was 100 years ago? To what it was 10,000 years ago? And who are we to decide what is best for the planet and the ecosystem?

DAVID SPERGEL

My day job now is being a foundation president—of the Simons Foundation—but for most of my career—and I continue to do this—I've been an astrophysicist who observes the universe. My work involves looking at the microwave background, the leftover heat from the big bang, the oldest light in the universe. When we look out in space, special relativity tells us that light travels at a finite speed. We see the sun not as it is today, but as was eight minutes ago; a star four light years away as it was four years

ago; the Andromeda galaxy as it was a million years ago; some distant galaxy seen with the Hubble Space Telescope as it was 10 billion years ago. And my own work is involved primarily in looking at the microwave background, which shows what the universe was like 13.8 billion years ago, roughly 300,000 years after the big bang.

The second part of the story I want to talk about is general relativity. General relativity consists of two ideas: matter

tells space how to curve, and the curvature of space tells matter and light how to move. The first piece of evidence for general relativity is from over 100 years ago, the great eclipse observation of 1919 that showed the visible positions of stars displaced by the sun's gravitational field. But this works on much larger scales. When we observe distant galaxies, the image we see of a distant galaxy is affected by the matter along its way. And when I started to think about the nature of these objects and how they evolve, I saw, in a sense, a similar story. The universe itself…As we go to observe the early universe, what we see is affected by the experiences that light, in this case, has as it propagates from early times to us. And that propagation is interesting in and of itself.

And when we think about restoration of images, which we do, for instance, when we take an image of a galaxy with the Hubble telescope and restore the circular, what we call the Einstein, ring. What was the original galaxy image before it was distorted by that foreground galaxy is one interesting question. But the process of understanding that distortion, for us, is actually sometimes more interesting than the original image, because that distortion tells us about the distribution of matter. And that's something we're very interested in understanding, because we know so little about the universe. The atoms that make up us actually comprise only 5 percent of the universe; 95 percent is in the form of what we call dark matter, or dark energy, and our most direct way of observing that is through seeing the distortions it produces. Our process of restitution tells us about this.

As I mentioned, my own work is on the microwave background. We look back in time to when the universe was very hot and dense, and our observations—because we go so far back, we think of them as looking at the baby-picture of the universe. My camera is the Atacama Cosmology Telescope. It's

up in the desert at about 17,000 feet above sea level, both very dry and above a lot of light pollution. We make images of the microwave sky, the leftover heat from the big bang. We look for patterns of intensity, how bright it is in one place but not another, and we also learn a lot by the patterns of polarization.

Light is polarized, so we can map that as well. And then we take these images and we try to restore them. Just today we shared internally in our collaboration an image we took of a patch of sky and then reconstructed. It shows the distribution of all of the matter in the universe between here and 13.8 billion years ago. It is the work of restoration itself that teaches us a tremendous amount about the history of universe. It's a way in which we learn things about the dark matter.

MARLA SPIVAK

Wow. Well, most of the time I have my head in the beehive, and I'm thinking through the bees' eyes and not through my human lens at all, which is kind of ironic because I am human and I do have human eyes. But often I'm in bee space and actually prefer it when I get there. I do research on mostly honeybees. I do a lot of other work on all our other native species—honeybees, you know, aren't native to the United States. And I look at how their healthcare system works. They have social healthcare, and they're quite good at it. And I look at all the ways they can keep themselves healthy, and then I try to help them make sure that they can do that on their own so that we can have minimal human interference. They should be able to live on their own without us. Yeah. So, *conservation* is a really loaded word for me.

Let's segue into that question.

I'm really interested how for all of you, when these words

CONSERVATION/ PRESERVATION/ RESTORATION

kind of float across your screen—how are they meaningful, if at all, and is there a kind of variation among the meanings? Marla, do you want to just continue?

MS So, *conservation* is a really loaded word for me. Sometimes the words *conservation/restoration/preservation* are trying to hold onto something, where I want things to move forward and where they will move forward. For bee health it's actually…I really enjoyed Sendhil's comments on circular economy, because that to me was regenerative agriculture. That's the process of building soil so that you can have pasture for animals, you can grow food for yourselves, and nourish wildlife and soil, et cetera. Which is what we need to do to keep bees alive and everything else alive, including ourselves. So, conservation is in fact—and I think Jeffrey said it too, in his last word—something about not keep being stationary but moving on. And moving on in a really diverse way: the more diverse the better and diverse at every level and in every way that you can think about. And I think that's my hope.

JG When I was working at the Field Museum, many objects were brought into the collection. And for conservation reasons they're fumigated; there's pesticides—arsenic was put onto them in different times. And so they're poisonous at this point. And then when the tribal delegations would come to visit, they would see this as their ancestors being poisoned. The argument was that objects not be returned when there were not museum-controlled environments for them to return to. The idea was that if we return these objects to the tribes, they will just simply disintegrate and we will no longer have the object. But, first: what was preservation from the museum's

perspective was poisoning from the tribe's. And, second: that falling apart is what instigates either the remaking or the repair from within a cultural practice; in other words, it's part of a life cycle.

And, so, this idea of letting things age, letting things fall apart, and leaving be the knowledge that is necessary for this continuance is really what I took away from that experience. Drums should be played, garments should be worn, ceremony bundles should be unwrapped, a new wrapper should be put on, et cetera. It was a completely counter perspective to the museum's view of what is authentic. For instance, when you look at a ceremonial bundle, one of the things that really struck me—and this was a different time, and the bundles had already been taken apart and separated—was that the wrappers were really these kinds of timelines, everything from deer hides, smoke brain-tanned hides on the interior, moving through the economies of trade. There were government-issued blankets used as wrappers, but also different kinds of textiles coming from across the globe as wrappers. They really tell a story. And then the next wrapping that never was put on because the bundle was collected from a battlefield, and that next owner was never appointed. The story was cut. Even the absence of something can be revelation. Thinking about all this, problematizing some of these objects and materials, is really in an effort to awaken them to a dialogue so that they can transform into whatever is meant to happen next. Not that preservation, or conservation, should be the end of their life.

And is that what you meant by "authentic"?

Yes. I think authenticity is really to see the object as living, to see the object as having a birth, having a life. In art terms, in my time, in my formal training at the Art Institute [of Chicago], there was a real anti-aura critique of art making and object making. But artists were still always talking about the magic and the aura of what happens in the studio. The kind of alchemical nature of mixing color and painting and spirituality. But these were not things that we could talk about in a gallery or a museum setting. So this kind of engagement with the object is something that I started learning about in response, and have negotiated ever since.

I would say that it felt like risk-taking, initially, to say, "I'm going to look at this bag as alive. I'm going to look at this bag as having been suffocated for 50 years. I'm going to look at this bag as having been denied food, sun, air." That was such a radical shift. And conservation by its very nature, in the museological practice, is all about removing and stabilizing and creating stasis.

I love that Jeffrey, thanks.

Campbell, how does this fit in with the work that you do?

CM Yeah. Well, I mean, when I first thought about it I was like, "Huh, it doesn't work for me as 'restoration.'" "Preservation" and "conservation" made sense, in the sense that poetry is very backward-looking because of tradition. You're always going back to *Beowulf* and to the origin points to ask, "What is poetry? How can we understand what we're doing now without some sense of what poetry is?" And, of course, there's global poetries and all sorts of stuff. But, say, the poem that I wrote about *Guernica* and war in Europe—that poem is written in a form called canzone, which is 14th-century Italian.

And why should I be writing a poem about Picasso and *Guernica* and war in a form originated by the troubadours in the south of France and then imported into Italy? Well, I don't know, but that's what we do. We preserve the form, and we feel like that's an important aspect. But I thought, "restoration"? I don't know if I see that one at first, but then I started to think about it differently, which is that really our resource as poets is language. And we're not trying to preserve the…I mean, the English language is not a preserved language. It's not a language with a cultural council that allows new admissions. It's a polyglot language that absorbs and grows all the time.

Language is always being appropriated by powers and used against us, in ways like…commonly we see that in advertising, and the language of corporate sales is constantly…they're seizing words: "Coke is life," "Coke is it." Without this company, we all basically couldn't exist, or happiness would be outlawed! I do think that it has traditionally been something that poets believed they were doing—to try to restore authenticity, to use Jeffrey's word, to restore some sort of truth-value to language, because truth gets drained out of language very, very easily. We've seen that in domestic politics over the last 10 years. If you just keep saying that black is white and white is black, eventually you can succeed in confounding the very notion of which is the true answer.

Poets, I think traditionally, have tried to say, "Well, language is something we try to view a little differently, as an actual, elastic resource, as a thing we live within." And somebody has to try to keep it honest to itself, even though that word *honesty* is very fraught and very complex. And then that's also complicated by the fact that poets may be doing that, but nobody's actually paying attention to us doing that. So, are we really doing that, or are we only kind of entertaining ourselves? I do think we're doing that work of constant restoration, but how that broadcasts to the larger culture, I don't know. Because there have been eras when poets had positions of being listened to, and looked to, as some sort of arbiters, but we're certainly not in that position right now.

Poets as bees? Language as hive? . . .

SM You asked about how I first reacted to these words? Which got me thinking: I realize I've got a huge bias against the words *conservation/preservation/restoration*. And I think you mentioned this, Marla, and I thought it really made my bias clear to me. And your point, Jeffrey. And I'll tell you where my bias comes from. I grew up in India until age seven, and then Indian culture followed me to the US. Now, my dad was quite an exception to what I'm about to say, but Indian culture can feel stultifying at times, because of the weight of it. For example, pretty much every single person who's one generation before me had an arranged marriage. So, like my mom, my dad—they met when they were getting married. Their marriage was arranged. And you grow up as a kid in the US, like, "I don't want an arranged marriage." And that's frightening. And to me, the backward pull is what I always associated with conservation and preservation. That feeling that I'm being tugged back into something. And I will say that in the last two years, I've had a few experiences that made me realize I'm thinking about this in a biased way. I mean, everything is richer than your limited thinking of it. And the experience that really brought it out for me was realizing that I was a collector. I like to just have these little mementos of things. I have a memento box—I'm sure everybody does; we put the mementos in. And the thing about memento boxes is...At least me, I put stuff in, but I never look at them. I don't know what the point of it all is, but I put them in.

But one day I went back and pulled it out and looked at it. And it was like—do you guys remember this ad for NBC sitcoms? They were trying to get people to watch reruns, and their advertisement was "new to you." If you haven't seen it before, it's not a rerun. It's new to you. Now, these mementos in their box, when I started looking at them, the shocking

thing was it did not feel like being tugged back. It was new to me. I had moved enough forward in time that what I was discovering was entirely novel to me.

Even though it was me and it was an experience, it was not me. It was entirely novel. And that just got me to realize there's so many things like that. For example, a grad student from 10 years ago comes to me and says, "You remember this idea you told me you like?" "Nope; that's great; it sounds wonderful. Wish I had thought of it." They're like, "You told me." I'm like, "No, I don't remember that. It seems new to me." And there's this oddity of the mind that it is flushing out things so fast, even things that felt so firmly entrenched in my own life. It's my own cultural preservation in my life. Things that felt so dear to me three years ago, if someone could build a little wormhole from there to now and pass it forward, would feel novel to me.

And so I think it's part of why when I heard these words *conservation/preservation/restoration*, I'm like, "I just need to understand. I think I don't understand my own life." I would say I don't even know that I'm remotely anywhere near understanding them, whether it's personal things like mementos or even my own ideas. My job is to put together ideas into something that does something. To invoke Marla, I don't know that I'm a good ecologist of my own mind. I think that's one of the things that I've really been struggling, wrestling, with and trying to make sense of. I know I'm coming with biases. I think on the economics side *conservation,*

preservation, restoration have gotten a pretty bad association for all the wrong reasons. I think in the 1970s there were these discussions about how "we're going to run out of X," such as fossil fuels.

Economists being curmudgeons in the best of times, but certainly curmudgeons in the face of this type of bravado, there was a response that this was just foolish talk. Because, so the economists reason, as things run out, prices will go up and that will encourage conservation. And a new equilibrium will emerge. Who knows if they were right? But the fact is we didn't run out of fossil fuel by 1995, and economists walked away from this whole language of conservation-preservation.

But there has to be something to be understood here, whether it's the preservation of the resources we have, or whether it's the process of rejuvenation that Marla is describing. Are we building a sustainable system? What does that even mean? Or are we just accumulating this sort of leftover stuff? And it's clear that those are processes. I think I know large parts of social science, and I think it's fair to say that these processes are not well understood.

I'll just give you an example of how poorly it's understood, just as a very pragmatic example. So, in the world of computing, you will have big software systems. People don't really think about this, but something like, say, Microsoft Windows or Mac OS. If you're watching this on Zoom, some operating system is being run. That is a work that is in many ways very impressive, in some narrow sense. And here's why. A lot of person-hours

went into writing millions of lines of code. It was like stacking bricks up to build the pyramids. They built this enormous thing, and they put it together in a decentralized way. But when you build at this enormous scale, something accumulates called "technical debt." Technical debt is clean-up work that has to be done eventually. It's like deferred maintenance with a bricks-and-mortar building. You want to keep your code clean so that you can actually have other people work on it. But locally, you're just like, "Well, right here I'll just get by." And so this mountain of code builds up where someone, at some time, is going to have to go back and clean it and make the thing sustainable. Nobody understands technical debt. Nobody understands how it builds up, how to keep it from happening. There are billions of dollars of costs hanging on this situation. We don't know. It's just human behavior. And we don't know how we as people can prevent the building up of this technical debt. It leads to serious things like the Y2K crash. And we don't really understand it. That's a way to think about *conservation/preservation/restoration* and its costs.

The word *conservation* to a physicist has a whole different set of meanings. Not only that, it is central to our understanding of physics. So, if I were to ask what is the one concept that is the basic of element of modern physics? It's Noether's theorem, which says that whenever you have symmetries, you have something that is conserved. And again, to just use another word that we've heard in a different context, we talk about translations. I can look at the laws of physics here and

the laws of physics there, and the fact that they're the same, that they're translationally invariant, they don't change, means that momentum is conserved. The fact that the laws of physics don't change in time…As long as they don't change in time, there's conservation of energy. As long as the universe is, or what I'm thinking about is, symmetric under rotation, there's conservation of angular momentum. It is symmetries that lead to conservation that is actually the central concept of modern physics. *Conservation* is this incredibly powerful word that we're using in all these different ways, in ways that are central to our fields. I guess it's a different form of translation, right?

> Because, for instance, what do we preserve or conserve? Let's take an example. A year and a half ago, I had to restore a gold ewer made between the seventh and ninth centuries in Tibet. How do you approach that? I did tests of all kinds—radiography, everything. This was made by somebody in the ninth century, and it is influenced by Persian, Sassanian, Chinese, Sogdian. It was on the Silk Route to China. How do you approach this? Okay, I read all the technical reports. I am coming from a Eurocentric education, so what do you do? Okay, you go immerse yourself in the poetry of that period, in the philosophy of that period, in the life of those people, and you try to imagine it. For instance, I give you a stupid example. But on the top near the handle, though through the tests you cannot find it, there was a red powder, and obviously it's an oxide of arsenic. The scientists ask, How could they use it on a drinking thing? Well, the Chinese people, one day in the year,

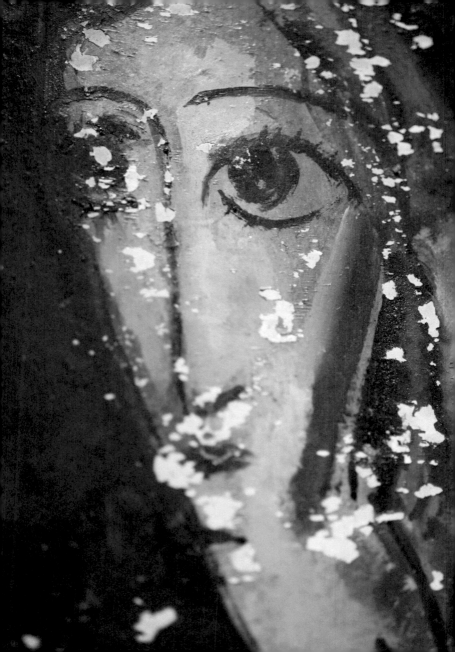

put arsenic in their wine as a ceremonial thing. And also, if we analyze in Greece, they know very well, 400 years BCE, that arsenic was a poison, but in moderation it was used for many health problems. So, we have to... In other words, representing DNA, preserving the cosmos, yes; but we also want to possess the human expression through the centuries of those people. If you read the poem *The Conference of the Birds*, you are there in the 11th century. You're there in Persia. So, that's the thing. As a conservator-restorer-preserver, you have to abandon your education and try to get into the world of the thing.

> Some of the subject matter of my work is directly engaging with these ideas, like in *Oak Flat*, about land conservation, cultural preservation. I have a new book out, actually just yesterday, a children's book, which is maybe the most on the nose investigation of this. It's called *Time Capsule*, and it's about who gets to write history, what we remember, how we remember it. The maybe self-indulgently long author's note goes into the history of "time capsule," both the term and the idea, and looks at other types of human projects that have done parallel things, but also accidental time capsules, like Pompeii. I think my work is trying to hold on to the ongoing relevance of the printed book in the digital age.

AT THE RUINS OF MIAMI BEACH

A Poem by Campbell McGrath

1.

The surprise, in retrospect, is not the city's vanishing
but its ever-having-been, the unlikely dredging-up
from salt-muck and blade-sharp undergrowth
of something with a passing resemblance to land,
however permeable, however tenuous the plan
to pinion mangrove sandbars into skinny islands
elaborated over the century with golf courses
and finger canals and a glut of grandiose, stage-lit,
palm-encircled trophy homes, a great dream
born of the ocean and to its briny bosom returned.
Such shall be the future's judgment, tut-tutting our folly,
which indeed it was, foolhardy, laughable,
a contract between the devil and the mortgage broker
and the deep blue sea. A lesser paradise it may be,
but there are seasons here when the ocean
takes your breath away, no colds or hots,
only the ambient warmth of wind and tide
harmoniously synched to the body's inner weather.

There is that moment on the still-warm sand,
in the just-gathered darkness—
 cruise ships blazing
against the shadow-milk of the horizon, sunset clouds
lush as skinless jewels—
 it's time to go, your friends
are folding up beach chairs, re-corking the wine,
but how can you leave when the millionaires' condos
shine so invitingly (though you were not invited)
and the hotel lights and the lights of inbound airplanes
and of stars flying outward toward the edge
of an ever-expanding universe glitter indistinguishably,
or are such distinctions simply irrelevant in paradise?

2.

Our house, with three decades of family history
etched into its sills, cartouched into once-wet pavement,
sits precisely five and a half feet above sea level.
Not bad for these parts—five feet—but not enough
to survive the trials to come. Looking back,
our lack of guile and imagination seems absurd.
Have we gleaned nothing from history, from philosophy?
Permanence is an illusion, I learned years ago
from Basho and Heraclitus and possibly Steve Miller.
Time keeps on slipping, slipping, slipping into the future.
But applying ontological truths to one's own life is, yes,
slippery business, irksome and counter-intuitive,
so we resist, cling to the moment, struggle to preserve
what we have known, familiar comforts, the status quo—
a trope of heart-breaking naivete.

To preserve
apricots, metallurgical techniques, Yu'pik dances
or the story of Fred Hampton is to carry forward
the saga of the species, but to ensure our continuance
we need to privilege the future over the present,
the lives of persons to be born in 2279
over the lives we are currently enjoying, saddled with,
frittering away–whatever the appropriate verb.
It may help to frame the conflict as a familial drama,
great-great-great-grandchildren vs. the size
of your current automobile, bank account, caloric intake,
but what's at stake is hard to overstate–icebergs
and polar bears, social collapse, capitalism,
the atmosphere, human survival. Everything.

Sea-level rise, climate change, global warming:
it's a problem in need of a catchier nickname,
a tagline to match the competition's bravado.
Earthquake! Mudslide! Wildfire! Volcano! No,
ours is the laziest of disasters, less a cataclysm
than a seizure of assets, an implacable dispossession.
We don't even need to get our flipflops wet,
the ocean only wants to borrow our pails and shovels,
our beach towels, beaches, cities, coastlines.
To the young it seems
an injustice inflicted upon them by self-indulgent Boomers,
to me it feels tragic yet strangely inevitable,
an unlucky state or two.
I'm finding it harder, year by year, to separate my concern
for the planet from the specter of my own mortality,
projecting the movie of my melancholy
upon the ocean's screen. Why not? We are both
middle-aged, me and the Atlantic, we should be cranking
ZZ Top tunes together, eulogizing glory days.
I recall a world before Starbucks and it remembers
the breakup of Pangaea, the sundering of continents
into puzzle-piece refugees yearning for Gondwanaland.

It remembers the Zanclean Flood, when a ridgeline
it had rubbed against for ages—like a horse scratching
a monumental itch—buckled, and at first a trickle,
then faster and faster a caterwauling influx
sluiced into the adjacent basin, creating, by happenstance,
the Mediterranean Sea. And I remember what?
Obscure commercials from Saturday morning TV.
King Vita-man, have breakfast with the king.
King Vita-man, as the jingle jangled relentlessly
through my child-sized brain, a regal proclamation,
certainly, though I was never sure of what, or whom,
he was monarch—breakfast cereals? Vitamins?
Vita-men?

Now back to our program.

At no point
was I encouraged to interrogate industrialized farming
or carbon emissions or the fragility of Antarctic glaciers.
at no point did I possess the pertinacity to question
the consumerist ethos within which I was submersed–
Palmolive? You're soaking in it! – at no point did I wonder
if crucial lessons for our future might be encoded in.
say. the Zanclean Flood. Compared to which.
 in all honesty. our current troubles seem little more
than ebb and flow.

3.

If we were fish, or mermaids,
salt water would be central to our histories,
but we are earthbound and the sea remains unknowable,
innumerate and therefore un-bribable,
and things that money can't buy make us nervous.
The ocean's text resists the story teller's task,
preferring continuity to climax, repetition to narrative
acts;
journalists substitute depth for profundity,
oceanographers mistake chemistry for romance,
historians content themselves with ports and tonnage,
naval battles, the evolution of lateen rigging.
The sea is too self-assured in its orthodoxy, too hard
to pin down. You can't sink your teeth into it,
square its edges, work it with gears or levers, mill it
or drill it or quarry or crack or hammer it flat.

Pangaea split apart 200 million years ago.
The cleft between lands that became the Atlantic
followed the seam of an ancient proto-ocean, Iapetus,
that lived and died 300 million years before that.
You can trace the mid-ocean margin on a map,
visit the continent-straddling rift in Iceland.
There are rocks in North Africa and Nova Scotia
that match like fragments of a broken eggshell.

Fast forward: people evolve, history is born, society
spawns injustice and language begets proper names.
The North Atlantic was once the Great Western Sea,
the Sea of Perpetual Gloom, the Sea of Atlas
and the golden apples of the sun and the royal blue dye
of the Murex trunculus, a sea-snail prolific off Mogador
which lured the Phoenicians through the pillars of Hercules
to discover more water beyond the water that was.
As if imperial profit has ever needed prompting.
As if purple cloth proved the sanctity of noble blood.

Odd that a carpenter born in the dry gulches of Judea
might determine the fate of a distant ocean
with his catechism of suffering and redemption
and blind obedience to heavenly fiat, that the Cross
would cross it restlessly back and forth,
uniting in blood what salt water had kept apart,
Castilians and Aztecs, Dutch and Lenape,
the Fulani and the Ibo and the tall ships come
to carry them across a Christian pond into slavery.

Suppose the summer moonlight had struck a fatal blow
while Columbus dallied in the Canary Islands
with Doña Beatriz, La Cazadora, lovely young widow
with riches far beyond sweet water and safe anchorage.
Suppose shipworms, mutiny, gales, any of a thousand
contingencies to divert his megalomaniacal rapacity
or temper the savagery of his evangelical zeal.

Florida's faux-heroic scion, Juan Ponce de Leon,
tagged along on Columbus's second voyage,
then served in Puerto Rico with fit ruthlessness
to satisfy his masters, slaughtering those infidels
who would not convert and later those that had.
On the scale of sociopathic violence he scores
about average for a second-rate Conquistador,
though his quest for the Fountain of Youth displays
a taste for magical realism or fathomless gullibility.
Anyway, when his big break arrived it came to naught:
the Calusa killed him with a poisoned arrow
before he could implant a colony on Tampa Bay.

History as a catalogue of conquering heroes is happily
dead and buried but its consequences endure.
However inept, Ponce's efforts gave Florida a name
and silhouette in the monster-strewn atlas of the day,
the ever-less-figmentary map of a trans-Atlantic future
inked in blood on sailcloth, a succession of European
flags and cannons until, yee-ha, Americanization.

Trivia quiz: name a famous Floridian. Anyone?
Tiny Hawaii spawned a president. Ohio has sired seven,
but we have yet to launch a single soul into any orbit
of power, any pantheon of science, industry, or art.
Zora Neale Hurston, sure, but she was born in Alabama,
as was our only noteworthy politician, Osceola.
Has any state contributed less to the republic's glory?
There is no New York hubris or Midwestern modesty
or Eyes-of-Texas self-importance. Florida has no mythos
or master narrative to bow down to, no Olympian aegis
to shield it from the glare of our eponymous sun.
There remain to this day enormous parts of Florida
where nothing ever happens. Nothing. Ever.
Fishermen troll away days from lime-washed causeways;
couples stroll the strand at dawn looking for sunrays
or false angels' wings tossed up by gentle waves;
ospreys make sly withdrawals of silver while pelicans
crash the buffet—not much beyond grouper sandwiches

with sweet potato fries and pitchers of cheap beer.
Satellite Beach. Malabar. Port Saint Joe. Manasota Key.
Since the Fountain of Youth ran dry, such is the essence
for which Florida has become rightfully famous:
haphazard quietude, casually gorgeous somnolescence.

Miami's relationship to the rest of the state is that
of a bull gator to his pond, the wolf to the little lambs,
the stripper at a church social full of unwary husbands.
Like old Dodge City, or the territory beyond the Pecos,
it is anarchic, predatory, venal, and lawless.
Also stateless: a pan-Caribbean diasporic entrepot,
a free city, like ancient Tarsus or medieval Venice.
It was – has always been – a peculiarly American refuge,
crossroads and liberty port, a place to escape
the wickedness of poverty for the ruthlessness of plenitude,
gravity-defying wealth that trickles up, up, up,
like groundwater percolating through the porous oolite
that underpins the entire soggy peninsula.

Miami is also: earnest, sensual, diverse, tolerant,
a free-wheeling, multilingual, multicultural model
for a forward-facing American society that for decades
seemed inevitable and now at risk of dying still-born.
It is a conundrum, a paradox, but hardly an enigma.
Miami wears too little clothing to appear suggestive.
It is a beautiful body enjoying the beach, oblivious
to sensory inputs more complicated than warm coconut oil,
sunlight on water, the faint buzz of airplanes
towing signs for nightclub DJs and imported rum.

4.

From the western rise on the Julia Tuttle causeway,
where the intracoastal waterway passes beneath the bridge,
you look north across staggered stretches of Biscayne Bay
chopped into blue and crystal-green quilting squares
at clusters of tall buildings ranked as far as the eye can see:
nearest are block-squat condos on Treasure Island
by the pelican sanctuary, their concrete balconies
emblematic of 1970s tropicalia, built as warehouses
for surplus grandmothers now occupied by personal trainers
and dental assistants commuting to work in pastel smocks;
next the plutocratic, designer-brand, beachfront palaces
owned by seasonal money from Wall Street or Caracas;

and still farther, past the missing tooth of Haulover Beach,
past the dreadful, Soviet-Lite megaliths of Sunny Isles,
a spray of tiny white spires diminishing ever further
into distant hinterlands, Hallandale, Hollywood,
the air so clear today, it might even be Fort Lauderdale.

Behind me, west and south, stands a primeval forest
of jack-pine construction cranes erecting ever-taller
walls of mirror-smooth glass for those desiring equally
a slice of beauty and a safe-haven for grey money
and apparently oblivious to the hazards embodied
by the azure waters they have come here to admire,
which is to say, not Miami Beach but Miami itself,
city of fallen carambolas and roosters in the parking lot,
city of striving and conniving and selling the dream,
city of traffic and amnesia, city of afterglow.

Horizon to horizon, it's a thrilling view, a panorama
that looks like what the future was supposed to look like
when I was a kid, gloriously Disneyfied apotheosis
for an era that thought technology a single-edged sword
with which to cut a path into the Space Age.
My mother, god love her, believed that vegetables
grew inside tin cans and TV dinners would prepare us
to be astronauts–the tinfoil, I guess, had corrupted
her common sense–and yet, is it not a fact
that even as the ocean consumes me I shall recall
the taste of Salisbury steak with mushroom gravy?
It's right there, with the Hungry-Man pot pies,
at the back of the freezer in my mind.

Memory, as Plato knew, proves a better preservative
than whatever toxins Swanson poured into its goop
(e.g. butylated hydroxytoluene), but is Mnemosyne
or Pandora the more apt figurehead for our ship?
Will the future view us as technocratic savants
or oafs bamboozled by money's deceitful abacus?
How will we choose to act, now that we know the costs
of inaction, with justice or servility? Will we save
walruses, Micronesia, or Miami Beach?
Are we better off embracing creative destruction,
regeneration from the ashes, bison trampling the prairie
to open ground for next year's bluestem and pasque flower?
Would we repopulate the bison commons if we could?
DNA sequenced from the fossilized bones of mammoths
might bring those magnificent creatures back from extinction
but would it be an act of restoration or innovation
to release them into a world unrecognizably altered?
And what do we expect from those shaggy pachyderms,
forgiveness? There is no state of innocence to return to,
every pyramid is built on suffering and toil.
The future may be a hymn to desire rapturous as Song of Songs

but even as we engage with the past we re-imagine it.
revise it. polishing brass lamps into sacred truths.
memorializing what we value or regret undervaluing.
exiling unwelcome facts to the gulag of forgetfulness.
Which modern wonders or debris fields will endure.
as flakes knapped from flint hand-axes? Crypto wallets?
Revenge porn? Real Housewives of the Abyss?
When the cultural anthropologists sought to document
the Yu'pik village displaced by melting permafrost
they catalogued walrus tusks and ceremonial beadwork
alongside Doritos and boxes of Irish Spring soap
because they were artifacts of that place and time
and there was no intellectually coherent method
to privilege traditional objects over modern detritus.
Cultural value is relative. change is inevitable.
permanence is as illusory as. well. permafrost.

5.

Not all disappearances are shocking, mysterious,
or unexplained. Unlike Pompeii, we were forewarned,
and unlike Noah we chose to ignore the portents,
blissfully pagan in our sun-worship, and so condemned.
Miami is no Atlantis. It will vanish clumsily, painfully.
Failed sewage systems. Corroded electrical grids.
Streets transformed to filthy canals, malarial, piratical,
a charmless Venice. Florida will drown because
porous limestone cannot withstand an age of rising seas.
Miami will disappear because it is a bauble
and the days of easy luxury are drawing to a close.

The Age of Oil will end, the age of plastic vortices,
the age of exploitation and appropriation,
of personhood denominated in dollars,
the Age of Denial but not the age of human folly.
As surely as a city is founded it will come to be abandoned.
Vanishing is an act for which we practice from birth.
We grow old surrounded by familiar faces or
they move to the Villages and we age among strangers,
but you'll never be lonely with the ocean for a neighbor.
It's always stopping by to borrow a cup of sugar,
chat about the kids, and flood the garage with storm surge.
Miami Beach rose dripping from the sea, not a place
but a palimpsest, a century of footprints at the tideline.
We've been living in the ruins all along.

Of course, it means nothing to found a city,
to fix a name upon the sea, to label and map,
divide and conquer and colonize,
as if all water were not part of earth-encircling Okeanos,
borderless, unbaptisable, circumpolar, indivisible.
Of course, it means nothing to delimit an Atlantic domain,
Inishtrahull to Cariacou, Gomera to Saint Brendan's Isle,
Islamorada to Meat Cove and back again.
Of course, it means nothing and everything to me.

Here is my mete point, my cloak and staff, my remedy.
I meant to awaken from the dream of my life
and astonish the multitude with acts of derring-do
but the sky was ink-blue come morning
and the dog wanted walking and the eggs smelled
so good you had to sit right down and eat them.

So it passes, piling sand bags along the levee,
chopping down trees in the forest of years,
kneeling and offering all there is
to offer up to the gods of everyday disorder.

5 o'clock, or close enough.
My work is done.
Time for a walk to the beach and a swim.

Stanley, you talked before, in your self-introduction, about working on stories that haven't been told or were mistold.

So

CONSERVATION/ PRESERVATION/ RESTORATION

are these categories that you consciously work with? Or how do they fit into your work?

NS No, they're things that I've never thought about before in my own work. Really, in some ways I'm trying to tell stories that I feel are important that we know. I think that so many times people that we interview have been elderly; my wife calls it the kiss of death when we interview people, because every time we make a film, people pass away before we finish the film. And so I guess that in some ways we're preserving their stories, and it's an act of conservation. But we don't go into the films thinking like that.

But also I think that if it is an act of conservation and preservation, then we're doing a really bad job of it, because we may interview somebody for two hours, three hours, and then we end up using maybe five minutes of their interview in the film. Ninety-nine percent of the time the rest of the interview goes unseen, although more and more we try to make it available to people. But the rest of it just goes into the ether and it's never seen. And so their personhood is boiled down to those little clips that we use in the film, and that's it. But I guess that if you take the big view, we actually are preserving the stories. Like in the Black Panther film where we ended up preserving the story of the Black Panthers in a very different way. And the story of Fred Hampton, which could then be used for other films and in other ways.

So, even though I don't think about *conservation/preservation/restoration*, I guess it's what we're doing, in some ways. But in making the films, it's not like, "Oh, we're going to go preserve this story, or we're acting as conservators." We're really trying to get people to tell their stories. The conservation, the preservation, is secondary.

 Yeah, I think I would acknowledge that initially when you raised the ideas of preservation and conservation and restoration, it made me think maybe not of people, but more of wildlife. I think that's the connection that I have in my mind, the human effort to support lives of other species. Those particular words make me, personally, think of green spaces or earthy smells or humans that care about species that are different from them. And I think that in my experience there are at least two places where that connection came to be.

One is from when I was a child: I would go hiking with my grandmother in Valley Forge, which is a national historic park outside of Philadelphia, Pennsylvania. And in that space, about halfway through the hike that we used to go on, there would be this wonderful meadow that was just full of butterflies. And every time we went, we knew that there would be butterflies there, and it was a place where they could be, and they could live and they could be happy and we could always watch them. So that's one connection that I think was drawn quite early. But then, also, as an adult, I would often go walking along the bluffs in Santa Barbara, California, which is where I did the postdoc before my faculty position. And on those bluffs, there's what's called Elwood Mesa, which is a 230-acre open space that includes about 10 miles of trails. And in those trails is Goleta Butterfly Preserve, a place where between every November and February more than 100,000 monarch butterflies migrate and spend their time. It's 78 acres that they take over on the north side of the mesa. I really loved the fact that the mega-mesa provided a haven for the monarch butterflies, a place to land for a few months before flying off to somewhere else.

There's always been this connection for me between those three words that you described, *preservation, conservation*, and *restoration*. Something that's living, which I think connects a lot to what Stanley was just saying. And I guess if I take that idea and try to bring it a little bit closer to the work that I do, first I'll admit that I did not, before this invitation, strongly view my work in the context of preservation or conservation or restoration, but it didn't really take long for me to realize that my work in complexity science has a unique and maybe interesting intersection with these ideas that I'd love to raise today.

In particular, one of the key complex systems that I study is actually science itself. I study how scientists interact with information and with one another, and how they share their findings in support of the process of discovery. And in that work of studying how science happens, I'm really interested in how the stories of science are preserved—or maybe wallpapered over—and how we can restore the original stories of science. So, in fact, I think of my work as the work of preservation and restoration in that it seeks to uncover and mitigate biases in the way that science is recounted, the way that science is mapped, the way that science is engaged with.

And these biases are such that women and other gender minorities, as well as people from marginalized racial or ethnic groups, are systematically excluded from the stories of science. In that context, I think preservation would be attained if biased engagement were mitigated such that the discoveries of all scientists were engaged with equitably, and then maybe restoration would be the process of restoring the stories, restoring the discoveries, restoring the findings that have been lost by histories and structures of biased engagement. That's where these concepts come into play in the work that I am doing now.

EW I mean, I think for me, part of the reason why I feel suspicious of the terms, is that it seems to me that within classical studies they're so closely associated with a particular group of privileged white European men in the 18th and 19th centuries sort of saying, "We get to decide what antiquity was, and we are preserving antiquity, and all of the classical/Western—meaning white—tradition belongs to us." And then there's a sort of snobbery that's inherent in the idea that the term *classics* refers to a classist discipline. Or that in the past it's been the discipline that somehow conserves or preserves. And all of those questions are totally wrapped up in an idea that only certain people get to interpret, reinvent, respond to, read, and translate these ancient texts.

And the tradition belongs to a small demographic. Of course, that gets into issues of scholarship, issues of interpretation, issues of translation, as well. I mean, it seems to me that part of the reason I've sort of hesitated about the terms is just that I think it's hard within both translation studies and within classics to talk about some of the issues that have already come up with each of the other speakers, about how preservation actually involves something dynamic; it involves choices, and it involves values. It involves choices about what stage you are going to preserve, what moment in history you are going to preserve. All of those things seem to me so fundamental in thinking about how we interpret, translate, respond to, and reinvent ancient texts.

 So, everything you're saying right now presses a lot of buttons, but it sounds like something we can talk about later. My initial response to that trio of *preservation/conservation/restoration* is pickles. I love pickles, but I used to have a kind of thing, when I was

translating medieval Hebrew poetry from Spain of the 11th century, that I was interested in the contrast—this is when I would give talks or readings—between pickling and preservation. In a translation, I don't want to stop the growth of something and say, "This is the specimen, and we're going to make it last like it was in this jar, and here it is, here's the verbal equivalent in English." That seemed to me to be a kind of death, even though I adore eating pickles.

I wanted a translation that would somehow encode that same kind of transformation you were just talking about. That when the conservator deals with an object, that change in the process of transformation is built-in, is understood as part of the translation, the transfer to a new place and new time and new language.

My first association was to the negative one of pickling, but of course it immediately then leads to the antidote to pickling, which is a preservation that preserves life and the possibility of change. Really, life is defined by that possibility of change. More generally, I think everybody said this in some way about conservation, and the environment is in a kind of crisis. Preservation—I think of the self. I tend to say that the older one gets, the harder it is to preserve responsiveness and the ability to respond and to respond freshly and newly and to not become pickled. Speaking of memory…I think of self-preservation a lot.

Restoration gets a little more complicated right away, because I first think of ruins or history. I used to think a lot about—especially when it's translating older work—what you do with the partial ruin. Do you fill in the gaps? There's a lot, again, we can talk about later. But then quickly my mind went to the 23rd psalm: "He restores my soul." Right away, restoration became a kind of transcendental, or in some other way nonphysical, category.

I deal with kabbalistic things a lot. And one of the classic paradigms of kabbalistic creation is contraction, a divine contraction, in order to make a space in which something can exist. The creation of a negative space. In it, a first attempt at expression, sending out of some force into that negative space—it's not working, it's chattering, becoming too much, the space cannot hold what's being expressed. There's failure, or breakage. And then restoration or restitution or repair becomes the task that's assigned to people in the world to gather up shards or fragments of that fractured original attempt, or harmony, or attempt at expression, and make do with what little bits or microcosms that one can gather up and put together as a kind of echo or representation of that original impulse. That's a vision of restoration that ups the ante pretty quickly.

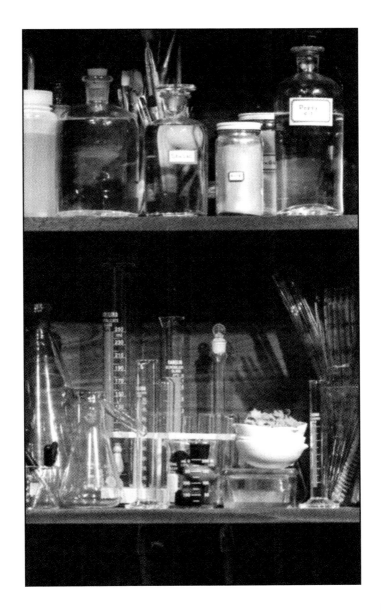

*Peter,
kabbalah and restoration:*

from the human side it's about putting the shards of the destroyed theosophic creation back together through human action.

Are you suggesting that the architecture of kabbalah could actually be described without much distortion as representing precisely this arc of terms that we're talking about?

That kabbalah in some sense is about—*or, more modestly, could be described in terms of—*

CONSERVATION/ PRESERVATION/ RESTORATION?

PC I mean, it's been increasingly the case for me that it has matched my model of learning and making. I know I can't speak for anybody else on the panel, but I've found it increasingly…I finished teaching my spring semester classes just 10 minutes before we went on. One of the classes I teach is Modern Jewish Poets. And it was a class of 18 really amazing students, incredibly engaged, and we talked a little bit afterwards about takeaways, what stuck with them. And several of the students said something like, "And we were reading Paul Celan and things like Jewish mysticism…" And I found myself saying to them, like, "Don't worry, you're not going to get it all once. This is a slow burn, but it's really worth it. You won't be sorry if you looked behind that door." And I feel that the paradigm which, when I was younger, I think I physically responded to as a poet and as a maker, has increasingly showed itself to me to be just, yes, totally profound. It works across many different fields. It's got nothing to do with belief per se, it's a kind of, as you say, an architecture.

So, with this, when you mentioned ruins, and then now when we're talking about the architecture of existence, it's almost like expanding the semantic field of

CONSERVATION/ PRESERVATION/ RESTORATION.

Because if we think about ruins and the literature on ruins and the depiction of ruins in art, there's yearning, there's melancholy, there's longing, there's scarcity.

If we now push restoration out into this kind of affective territory, is there some way that your working with those kinds of emotions could suggest a way to engage with

CONSERVATION/ PRESERVATION/ RESTORATION?

In other words, can we get at these terms, not so much through the terms themselves, but through their affective resonances for you in each of the ways you work?

PC Could I pick up on this? One of the things that really struck me is…Because the Hebrew poetry I deal with from Muslim Spain is an Arabic poetry—it's a kind hybrid of biblical Hebrew, medieval Hebrew, and Arabic poetics and sort of Arabic and Greco-Arabic philosophy. It's this real sort of mix of things. And at the heart of it, in Arabic literature, there's a kind of motto that runs through much of medieval and on into present times, which is that "poetry is the *diwan* of the Arabs." And *diwan* is an Arabic word that can mean a lot of things, but it's often translated as "poetry is the archive of the Arabs"—the repository of cultural value. And that's an incredibly sustaining thought, given the place of poetry in modern American culture. Thinking that Arabic poetry is the *diwan* of the Arabs can help a poet get through some dark times. But there is that sense…I was struck by Stanley saying that, oh, he's throwing out 95 percent of what he shoots. And thus that actually you're not preserving or you're not preserving well. But I think when I'm translating, especially, older work—but even when I'm writing, if I'm writing a historical-based poem, or a poem based on older materials—I'm picking out such a little bit, sort of back to that kabbalistic kind of architecture you're talking about. I'm asking so little to represent so much. Those choices, they mean everything in terms of whether that life can be transformed and go on living.

Campbell, turning this to you: Is poetry the diwan *of the conservatorially-minded? Is poetry a way of thinking conservation?*

CM I don't know. It's a very good question. We'll find out. I guess for one thing, because now these ideas have been planted in my head and I'm trying to figure out a way to do such a thing. But I mean, they can do the…We can ground abstract ideas. That part of the question I have a very specific answer to, and that's through images. I mean, we can say war is terrible; Vladimir Putin is a tyrant. But a photograph of a dead child in the rubble speaks much more loudly than any amount of words we can throw at it.

So, we can ground abstractions and large ideas in images through language or through visual art. Can I write poetry conservationally? I don't know. I mean, I have. It's a set of topics I wouldn't have thought about, except that I have been really engaged in writing about sea-level rise, and specifically how it is going to wipe the slate clean of the places I've lived my whole life and continue to live in. So I'm…I, ah…I don't know the answer, but I'm going to engage with the process. And all the answers are revealed in the process anyway. You can't think your way to an artistic outcome. You have to just get in there and start making and see what happens.

Taking this idea of finding conservation lurking in places, as if disguised or hiding beneath the surface of other conversations or conventions:

Sendhil, reading your book on scarcity, it strikes me that one could look at scarcity as a conservation discourse, right?

It's like the discussion of ruins in every culture. Yes it's ruins, but talking about it means talking about what has been preserved.

Looking through the lens of scarcity means seeing what we choose to keep when we are under pressure. It could be another way of talking about conservation.

SM What's happening might be—I'm just, this is pure speculation here, and it's totally just riffing off what you're saying, Peter—it might be that much of what we look to conserve creates this feeling in us for that word. Where we fail to look to conserve is where we find ruins or problems. In a way, it may be that the lens of conservation, and the word *conservation*, is just not being applied to enough things. By looking at ruins, we might, in fact, figure out the things we might be more excited to save. That way the word *conservation* could have more positive connotations for us.

I think one place where you see this is language. Everyone feels incredible sadness when they hear about a particular language that's no longer…when the last speaker of "X" language is dying. I mean, there is something so sad about that, and the loneliness of being the last person to speak this language, because when a language dies, *it* doesn't die. It dies with one person being the last person to speak it. That, I think, is an example of the ruins that you're describing.

I was thinking about languages earlier, as you were, because, well, there's so much language rejuvenation and writing within Indigenous communities. But I thought it was also interesting when you were saying earlier that we're—these aren't your exact words—but that when we decide to act…I see so much fear in conservation and preservation, when it's that fear that it's the last. It's the fear that it's going to impact us negatively. Our comfort is going to be impacted. Our safety is going to be impacted. Only then do we act.

The other thing I think about is how all of this shifts our experience of time. There's something about this kind of technical debt, to pick up on Sendhil's term, which occurs because we're rushing to create systems that give us whatever impact we're looking for, whatever outcome we're looking for. We're not as thoughtful and intentional in this holistic building as maybe we should be. That's where this technical debt, or other kinds of debt or accumulation, occur.

We could tie that into so many things to do with contemporary life and media and capital and all sorts of things. But I think what's interesting about where I started thinking about conservation and preservation is that I know that the intentions are good. To try to save a cultural narrative, for instance. But, in fact, it sabotages the cultural survival. I keep thinking, during this conversation, that all of this, for me, is sitting just on one side or the other of fear, and how we experience fear. I keep coming back to that.

If we act out of "lateness," that means we're already living with fear and sadness. But are there ways to act as part of a positive practice? You know, we've gotten used to thinking that the best conservation is doing as little intervening as possible, but maybe there's a deeper point that conserving is always a kind of acting.

MS I do things very intentionally, and years ago, I burned off my front lawn and planted a prairie. It was one of the best days of my life. I planted all these native prairie species that are local to this part of Minnesota. This particular section doesn't have the grasses, but there's a lot of grasses in there. It's in front of my house, and the people in the neighborhood were…I was getting citations from the city for growing a weed patch. And this fear and—just what you were saying, how can this be fearful? It's, for me, absolutely gorgeous, but it is not under control, apparently.

This is conservation. There's so many animals and bees and things, birds living here, and the root system is conserving the soil. There's no runoff and there's water filtration and there's carbon sequestration, and it's all happening in this tiny front yard. I take this very literally and actively.

SM Marla, can I ask you a question that is…It's going to make me look super stupid, so I might as well just ask it. I went to this little thing near Chicago where they are trying to recreate the prairie, so that you can wander around and see what the prairie was like. And I read one of the little tags they have there that explain the prairie and so on. My question is, in the tag, the claim was that it was very hard for them to actually recreate the prairie. They really struggled with this until they had the breakthrough that their problem was they were trying to preserve, and for the prairie to actually exist, it went through these long periods of lightning-sparked wildfires. It was actually destruction that was needed for "preservation." Even if that's absurdly false, I'd just love to hear you speak a little bit about this because you must have a lot thoughts about it.

MS No, actually, it's either fire or buffalo. I enjoy running. So, early in the spring, I run through the front yard pretending I'm a buffalo. I don't know. I just run around and stampede the yard. It does need disturbance, and you have to follow its lead. When you're putting in a prairie like that, you can't decide how it's going to be landscaped, because it takes on this life and form and structure on its own. It's really super fun for me. I like chaos.

SM The economist Joseph Schumpeter had a phrase which I really love. Economists are not known for coining good phrases, so you guys might all think, yes, this is further proof of that. But actually I love this phrase, and if I was to add a fourth thing to your *conservation/preservation/restoration*, it would be *creative destruction*. He coined it, and it is actually just a fact about the economy that some amount of—a recession is obviously bad; it causes a lot of harm—but some amount of destruction is needed to allow the creation. You have restaurants doing a downturn. Some restaurants die, and that's sad. But, for the next generation of restaurateurs with new ideas for restaurants to come, having empty spaces and lower rents is pretty good. Schumpeter's idea of creative destruction has always stuck with me because it's pretty powerful.

JG I think it also happens in painting. Sometimes the only way to make a painting move forward is to create problems. It's the only way that a painting actually forms an identity; the problems diversify and, therefore, the responses diversify, and they find their own identity. That's how I describe the process from beginning to end. When a painting starts feeling too sorted out too early, and you realize you're resting in your comfort zone, this is where everyone says you just need to go in and do something to create a new situation for you to respond to. It's the same kind of intentional chaos that you create to navigate, and that navigation is through making marks with color and through the formal qualities of making a painting.

Debates about what and how to conserve often come down to debates about value—Marla's front lawn, or a recreated prairie in all its uncontrolledness—which is always going to be relative, and positional, and contested.

So how do each of you relate to the question of value?

CM I think it's really complicated, because what is the value of what Jeffrey does, or what I do, creating art? Talk about something that's contested or fraught! There seems to be an objective value to bees existing in the universe, and that we try to preserve that. Whereas I personally value art very highly, but I think I'd rather art cease to exist than bees.

JG A really quick story: When I was at the Field Museum in the '90s, there was a Yupik collection from Alaska that came in. It was a celebration ceremony. And the collection was of gifts that were given at the ceremony. And at the time—again, this is the '90s—it included things like Skoal tobacco, Whoppers, Doritos, Diet Pepsi, diapers, Irish Spring soap, all things that we could have bought at the local drugstore in Chicago. The archeologists paid more than the retail value of these objects, and then paid to bring them back to Chicago and the Field Museum. The Field Museum immediately said, "Why are we going to collect things that we could get down the street? And why did you pay more for them than we could buy them for? And how is this can of Diet Pepsi different from that can of Diet Pepsi?"

And it was really interesting to me. That was my first coherent experience with the abstract notion of cultural value. All of these objects had to be preserved and conserved. And so the Pepsi had to be drained out. Everything had to be made insect-free, everything had to be frozen and then put into archival storage. And so I just did a project with these accession cards that also had to be drawn in the traditional sense of anthropology and archeology and collecting. And I was not surprised to find out that none of these objects have ever been shown. They've never been included in an exhibition, and there was no question about whether or not we could borrow them.

But at the same time, during this 30-year period, there was always the question, "How do we represent contemporary cultures in their contemporary form?" And I was like, "this is that perfect example." And yet somehow it doesn't align with how we want to see or present these cultures. In my practice, I go through and think a lot about where the value either exists or doesn't exist. And much of the valued objects, the material culture of Indigenous cultures, continues to reflect the kind of pioneer fantasy going back into the 1900s, and then of course further back from that. If you look at auction results, that's where the dollars start going into the tens of thousands and the hundreds of thousands of dollars. It's not the stuff produced in the 20th century. What do I take from this? I'm most excited about the future of value and how to shape how we think about value.

MS I'd like to jump back to Campbell and I would say that in my mind, bees are art. So you can still have art. What bees do is art. I don't know. Nature to me is art. It's just gorgeous. But value, yeah, I run into that all the time, even within the bee world. I mean, there's controversy there, whether we should even really have honeybees here in the United States. After all, they're not native, and we should be preserving and conserving all our native species. And yes, we should. And not only bees, but all of our plants and animals. Yes, we need more of our native species. But to pit one bee against another bee in the value sense, I don't know what to do with that. We need all of our bees and, like I said before, all the diversity we can muster. So the value question I run into a lot, and I don't know what to do with that level of human judgment relative to what I do. I just try to ignore it.

SM This question's super interesting. I wonder if I can tie together a lot of what's said using this question. So, one way to think about at least my allergic reaction to conservation is just to ask who decides what's valuable? And what we're often talking about in this stuff—you mentioned this, Jeffrey, as well—is that there is some imposition by a person who's making the judgment for others. And if we thought about who's making that judgment, some of our allergy is not to conservation itself, but to the unilateral decision making by

the person who's deciding that this item should be conserved over this other one, or that "this is what conservation looks like to me," or whatever it is. But from that frame, I actually think we could probably talk about a meaningful version of conservation that doesn't have that problem. So let me go back to an impetus for why I put stuff in my memento box. At any moment in time, just in my own life, there is an imbalance of power. The only person represented is the me of the now. Future me and past me are entirely *not* represented enough in today's decisions. I mean, I try to think about future me, but I stay up late. And then I'm like, "OK, 6:00 a.m. self will have to deal with these guys because of...," I don't know. So, in some sense, future me and past me are not given enough weight in my day-to-day life. And I wonder if acts of conservation are in some sense a nod to the unheard and the invisible selves. Not just the unheard and the invisible selves of the people today—that's a form of marginalization—but to the unheard and unspoken-for future and past selves who are truly marginalized. And I wonder if our desire to conserve is an attempt to give a voice to those souls. It seems to me to be a healthy way to think about conservation: to ask, "Shouldn't future souls have some say as well?"

We'll come back to the topic of the future in conservation...

BS Well, I think from the perspective of a conservation biologist, or someone who's doing ecosystem restoration, the question would be, value to whom? Who gets to make this decision? What is valuable about an ecosystem? The very beginning of the conservation movement, in the early 20th century, had a very human-centric view of what was going on. And conservation moved forward, progressed, only because people saw that there was value, economic value. Aesthetic value, maybe, but it was always human-centric. That contrasts with the perspective of today, which is much more of an ecosystem-centric view, where the ecosystem has value in and of itself, because the existence of the rich biodiversity in these ecosystems actually helps them to persist and to survive. By propagating that richness, you actually cause restoration to happen. But restoration could be thought of as something that improves the value of something for the present. Restoring it to something that is more valuable in the present moment isn't maybe exactly what it was in the past, but you can conserve some of what was there, and also bring additional new value to it because there's a place and time that we exist in now that also is part of that ecosystem.

UV In the case of artifacts, who are the people maintaining those objects or those things for the future? What is the conservator's story? I think is very important for all of us to educate, for instance, the benefactors and the collectors, because when...Forget about the dealers, because the dealer will come, and he wants the perfect thing, but that's not what restoration is. Restoration is the aesthetic value of the thing, not the appearance. There is a difference between appearance and value.

Marla, when you were talking before, you introduced another word which we hadn't used before. You talked about doing things to your garden and not being in control. *That's another big word to put into the semantic field we're mapping here, because conservation and preservation do reflect a desire to control. I mean, nature is all about activity, entropy.*

It's happening whether we want it or not.

In conservation there's an unspoken role for control, maybe it's related to value—what you preserve, what you don't—and your role in the story. So, control—*is that a term any of you think about when you're thinking about your work?*

PC I do, in both senses. I mean that long poem I wrote about Freud's disciple called *The Invention of Influence*…And it's very much about the way, on the one hand, we decide…No, *decide* is not the right word. We have an active say, but not control, in building a world that's going to determine what influences us to some point. We have some say in that, but of course a lot of it is not up to us, and it happens unconsciously. But the interesting places for me in composition come with tracking that control and then finding ways to short-circuit it or abandon it or, say, poke some gaps into it. And it's when I feel that that control is being sort of let go and I'm being controlled, but am aware of it, that's when I get excited.

Yeah. I really like that you raised the point of awareness, Peter, because I also think that's a really important component of this—that, yes, maybe we want to control what it is that we are conserving or preserving, but at the same time, maybe it's just awareness of what we are doing anyway that we didn't know we were doing and maybe don't want to be doing. And maybe it's an awareness of the other ways in which we want to live, or the other ways in which we want to engage with the past, or the histories of our fields. So I think control is one way to think about it, but also just awareness of how our actions are already being driven in one particular direction by histories and structures of society. Being aware and then choosing what it is that we want to do that might be different. Complementing control with awareness feels important.

Yeah. I think that one of the things that I tend to do is go into the filmmaking process really open to people's stories and the footage that we find. We don't go in

with a tight script, like, "We're going to do this and that." We kind of have the outline only. We go in with not a lot of control, but then as the process moves forward more and more, I think I take control of the story more and more, until finally, hopefully, I'm in complete control. That's what I'll say. When I see a film I like, as a compliment to another filmmaker, I'll be like, "That filmmaker was in complete control of the medium."

That's what we want to do, but we also want the illusion that I'm not there at all. That it's not being controlled by me. The things that we're trying to do in the stories we're trying to tell—it's not the Freedom Riders story as told by Stanley Nelson; it's not the Attica story as told by Stanley Nelson. It's just the story, although, yes, it is made by me, but we're trying to take ourselves, myself, out of it and at least give the illusion of the story controlling itself.

 I also relate to that idea of push and pull between letting go and taking control. And I think for me it's sort of phases of the process. I mean, if I'm going out to report something, I want to be surprised, I want to be taken out of my own assumptions and just respond to what I'm gathering and be like Stanley, staying

super open. And then…and then I might bring all of that back, and at that point it's about editing and structure and imposing some kind of something very deliberate on all of these unexpected gatherings.

JG I feel like, in truth—and this is one of the big lessons that I see a lot of people learn when there's a breakthrough moment—it's when you realize that when you relinquish control there's an engagement with your environment that usually results in something positive. But it is a counterintuitive decision. The discipline is to step into an unknown space, to step into a void space and to trust. These are all counterintuitive reactions to our contemporary society. It's not encouraging us to trust. It's not encouraging us to navigate the world with our body in a holistic way.

CM I think *control* is a good word because, at one level, I mean, the real thing is that permanence is an illusion. I mean, the whole notion of preservation and conservation is entirely relative to a frame of reference, measured by a human life or several human lives. When we step into different frames of reference, we realize how meaningless they are.

I was at a poetry reading a year or so ago by Gary Snyder, who's a famous poet, but also very famous as an ecology guy who lives off the grid in the Sierras and has been from the '70s onward. He's revered as a naturalist as well as a poet. He was giving his talk and then someone asked, "How do you feel about the future?" He said something like, "Well, I feel like 50,000 years from now Earth is going to be in great shape and everything is going to be really wonderful." The person who asked the question was like, "I'm so surprised to hear you

say that given how terribly we're doing all this stuff." He said, "Well, we won't be here, but I think Earth is going to be doing just fine."

All of our considerations of preserving and conserving can be relativized out of existence if you take that kind of view. That's why I always find reading books about geology very comforting. Because time is measured in these scopes of tens and hundreds of millions of years. They make all of your concerns suddenly feel so meaningless. But, nonetheless, we are human beings, and we do only have our kind of timeframe to really make sense of things. That's why we are even having this kind of conversation. If we don't think about conserving and preserving, then, somehow, we have relinquished control to this kind of notion of real time and change that is very threatening.

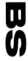

Just to simplify everything for my own mind, if I think of the ecosystem as the thing, then I am trying to focus on what I can best do to preserve that ecosystem. The answer is probably not to focus on the individual components but on their interactions. And ecosystems probably have multiple species interactions that are doing the same things, and the best way to preserve that ecosystem is to make sure that all of those services, all of those connectivities between the things that make up that ecosystem, are protected and preserved. And one way to think about restoration is not to think of it in terms of "let's bring back all of the species that used to live in this place," but "how do we recreate these interactions that used to exist that cause this ecosystem to be able to thrive?"

So do we need passenger pigeons in Central Park in order to recreate the ecosystem that used to be here? Probably not. But something that can come through and be as destructive as

passenger pigeons were every now and then would be great, not in Central Park, maybe, but in environments where you really do need your third-growth, your old-growth forest to be torn down so that new things could start up again. This is the role that passenger pigeons played in their ecosystem…

…Like Marla's buffalo?

It's these services, the interactions, that we should focus on if we can't pay attention to everything. And I don't think we can.

Part of my answer has to do with "what do we need to remember now?" I'm thinking of alternative terms that I tend to think about more often than these Latinate terms *conservation/preservation/restoration*. I tend to think in terms of memory. What do we need to remember that we might have forgotten? And I'm also thinking about the Greek terms. Mnemosyne, Memory, is the mother of the muses. She's a goddess who is a wellspring of creativity. So it's not that memory means we'll always think the same way about the past. Maybe it's a constant process of "I remember something" and that what matters in my memory now is going to be different from what I thought was the case yesterday.

I think, for instance, about how when I'm doing my translations of Homer, and I think this is also related to what Ubaldo is saying about the restoration of artistic objects, that I want the reader of my translations to have particular experiences that seem to me essential in the experience of the original, but might not be remembered in the same way in other translations that exist.

So, for instance, metricality or sound or the dramaticness of different voices. They might be there in the original, and I might not quite hear it in the same way in other translations of the same text. I might want to have that be resonant and remembered or not forgotten, because I think maybe this is something we have forgotten. Maybe this is something we need to remind ourselves of. Or similarly, if I think, as I tend to do, that a generation ago accounts of Greek and Roman antiquity tended to forget or not pay enough attention to the fact that there were people who weren't male elites who existed in antiquity, or that there were people who were enslaved *and* they were human beings.

I think those kinds of things need to be remembered. And I'm not sure if I see that exactly in terms of "we need to conserve X," because part of what we need to do is to say no to some earlier narratives or forget some earlier narratives in order to do a different kind of remembering.

Emily, I'm so glad you brought up memory. It struck me that we haven't talked about it yet, but that memory is an archetype for conservation. And in a certain way—not to go biological essentialist on the whole topic—the fact that memory is in us may predispose us to the importance of conservation. Dani, do you want to take this on?

 That's a really interesting question. I think that memory in humans is something that is interesting because it's so much more fluid and so much more dynamic than I think any of us were raised to understand. When we reach back into memory and bring something up we change it at the same time. We may increase the salience of certain bits, forget other bits, and so the engagement with the past is something that doesn't leave the past unchanged. It actually actively changes our understanding of the past. And so that means that there is a role for preservation and conservation and restoration in the sense that there's a place for thinking through what we choose to lose subconsciously and what we choose to retain, again subconsciously, and whether we can pull that up a little bit more into consciousness. This would let us engage with our past, and with the past of the society or culture that we are embedded in, in a way that is most productive and also most equitable to those around us.

Hmm… If we were to talk with conservators, what they would say is that every time a conservator works on an object, they change it.

The act of conservation is an act of alteration, very much along the way, Dani, you are talking about what happens with memories.

DB And just to jump in here. I think that this is really interesting, the fact that you can choose — that there are so many options and you choose a few and you don't choose everything. And this picking and choosing part determines what lives, or continues living. So, just to circle back to the work on what stories are told and what science is told, that's definitely…What we find, too, is that people — even in their scientific paper, in the beginning of their paper, or the end of it, wherever it is in their paper — they sort of write out the history of the bit of science that they're talking about, and they pick and choose what parts of that story to tell or what people to talk about in that story. And it's always a choosing, and it always means that some people are included and some people are excluded. Understanding how that happened and how to restore the narratives of people who are consistently overlooked, feels really important in this space.

LR I was just going to pick up on some of the threads about memory and poetry. My first book was a biography of a woman who lived to 106 years old. And when she was a child, she memorized a lot of poems — that was just part of her schooling. And she remembered those poems over a century of living. And she talked about how their meaning evolved for her throughout that time. She had saved these things; the words hadn't changed, but the meanings had changed for her over that time.

SN It's also really interesting that even with the stories that people are telling me on film, it's their memories, and their memories become almost calcified. So they'll have a really great story and a memory of what happened on that day. But if I ask them anything that is off topic, like, "Okay, so what color socks were you wearing?" They have no idea. They have no idea. And so, it's not only that they're telling the story, but they're telling a story that, maybe just to their own selves, they've told over and over again and that's the only story that they know.

We interviewed a woman recently who was 104, and she could talk about certain things over and over again. But if we asked her, "Well, what about that time where you were doing this thing?" She'd say, "I don't remember that at all." And then she would tell the same story over and over again. And so it was: she was halfway gone, but she was also locked into what she could remember and she would just repeat the story unasked, again and again. It's an interesting phenomenon.

PC Two things come to mind, then. One is the question of selective memory and that narrowing down. So the book that my wife, Adina Hoffman, and I wrote together about the Cairo Geniza, *Sacred Trash*, one of the things we were looking into is what led scholars to make these incredible discoveries throughout the 20th century, rummaging around in this kind of trash heap of some 400,000 documents—but also what led them to

miss other things that were just as valuable and right under their nose, and yet they couldn't see them. And it was astonishing how over this century people would discover the things that they were obsessed with and, in a kind of almost animal drive to get to it, would push aside anything that was getting in the way and label it as trash or of no value. And often those things would have that status of "trash" for decades, because people weren't interested. And then luckily before they were thrown out, somebody would ask, "Is there anything valuable here?" And somebody else would come along. The field had changed and now new things were of value.

So that's one thing. The other thing I think of is with my students, when I teach literary translation, which I love to teach, I play a game with them. The cliche about translation is, "Argh, it's impossible. You can't get all this stuff and all these associations and coloration, and you can't get it." So I say, "Okay, I've been doing kind of jujitsu, fine. You can't get everything. You can only get one thing, what's it going to be?" Everybody has to choose just one attribute of the work that they're willing to go to the mat for and get. And if you come away with that one, you say, "Okay, I've done a good job." And my feeling is, if instead of the blur, the mud of a little bit of nothing, you come away with the one thing—and maybe Dani will say this is a bogus scientific analogy, but it works in the humanities—and that one thing contains the DNA of the many things, then suddenly it starts to grow again.

Stanley, when you talked about some of the people who could remember one thing, one part of the story, and not other parts, as if they've told it over and over, I couldn't help but think of the act of constantly polishing something. So, the Italian Renaissance was once described in terms of the individual as a work of art. And with Dani, just before, we talked about this kind of parallel between the way memory works and the way the conservator works, where every intervention is a change. But maybe part of what we're talking about is that the way we humans conserve our memories is almost like treating them as works of art. We package them in a way that separates and isolates them, and then we polish them and we preserve them in a certain way— and then they travel, right?—more or less unchanging or only somewhat changing.

But, Stanley, back to the 95 percent on the cutting room floor, that image you invoked to diminish your role as a preserver, what about if we think of the realm of emotions? Maybe you have to leave some of the words on the floor, but can you capture and preserve the emotions that people have in ways that, like the DNA in Peter's last metaphor, can give the viewer access to the big picture, including the part that you can't show?

Yeah. I think you can. I think that's part of what I do as a filmmaker. But it's interesting because I'm now thinking about things almost like I never thought of them before. When you were talking about how people polish their memory like an artist with a work of art…So we're making a film, and we're putting together these pieces, and the pieces that we use are as if from the best artists, are from the people who relate their stories the best and are the most emotional. Now, are they really the most important stories? Is it really what happened? In some ways we don't know, and in some ways we don't kind of…Or we convinced ourselves that we don't care,

because we are preserving one reality. And so if somebody tells a great story, we're going to use it. Is it the most accurate story? The most important story? Maybe not. But then it becomes the most important story for a large segment of the population, because they only know the Attica story from the two hours that we put together. They're not going and reading books; they're not going and interviewing their own people. So it is really interesting, what's preserved of these different stories on film. And I guess that it's not only me as a filmmaker, it's all film, because I always say of a two-hour film that it's like the introduction to a book. It's about as much information as you can put in the few pages of the introduction, that's all it is. But it then becomes this document. And for so many people, Attica is what's in the film.

 This is *so* interesting because it strikes me that humans are a lot like piles of sand. Because piles of sand have different sorts of sectors in them. And some bits are more crystalline than others. And if a bit of the sand is more crystalline, it means that bit is always the same, and everything around it is always the same, and the pattern of interaction is always the same, and there's just a continuity. This feels like, Stanley, the people who you say have a story and they have it the same every time, and it's very clear and it's reproducible. Those people are important for you. Those sectors of sand are really important for scientists because they actually carry the memory of how that sand pile came to be. They tell you about whether the sand pile came from swiping like this [arm sweeps from right to left], or swiping like that [arm sweeps from left to right], or some other sort of structure that happened in the swirl of forces around them. Those crystalline bits are the pieces that tell you the history. Whereas the pieces of the sand pile that are not crystalline are the pieces that don't tell you the history; they don't have any memory left in them; they're all kind of just free floating. So this suggests to me that there's actually a correlate between the kinds of story that maybe are included and saved and conserved in a documentary film and the pieces of a sand pile that for a scientist tell us about what happened in the past, that provide the memory of how that sand pile came to be. This just feels cool because it suggests that actually humans are not that different from a lot of other bits of physics.

LR It's funny that you say that, Dani, because when Stanley was talking, the thing that struck me was the idea of thinking about memory not as an individual project, but as a collective project. And it seems like that idea of piles of sand is that kind of collective. And Stanley, if you're telling this story of Attica, it's not just one person's story, it's like you have many facets of different people who are all giving their perspective. And one thing that I really love to do, when I interview people, is talk to them together, not to do just one-on-one interviews, but to talk to three sisters together, families together. And then people trigger each other's memories, or they challenge each other's memories. I think that's a really interesting way to break through those kind of calcified anecdotes, and also to get that kind of multiplicity of perspectives.

PC Listening to this, it occurs to me that the polishing Stanley's talking about with some of his interview subjects doesn't just happen with our subjects—it happens with ourselves. And I know that I've become aware of myself as a transmitter of certain literatures, a transmitter of knowledge of that tradition of poetry.

After one has made a lot of these hard choices which involve a kind of violence and loss, a complicated calculus, and made those choices, made something change in order for it to go on being the same in the way that the novelist Jose Saramago talks about it, but then one starts to polish one's own story, and it becomes necessary to poke holes and restore the gaps in one's own knowledge. Otherwise it becomes a pickle; it becomes this polished thing that is no longer really interacting with the collective. And that's a very tricky, psychological, artistic space to be in, but I think it's the difference between artists who keep developing and artists who don't.

So, Dani, I want to follow Peter via Lauren back to what you said about the sand pile. It's a very suggestive picture of the mechanics of collective memory and how for an organism conservation is structural in the same way that Peter earlier presented conservation as structural in the philosophy of kabbalah. That is, in all societies, there always have been some people who are entrusted with memory, and they're like the crystalline pieces, and then there are others who aren't. But the individual grains of sand are not making choices, the way people might make a choice to work on themselves, to polish their story, to collect things, to make an effort to keep things, to become *keepers of memory, even if flawed.*

 And maybe there's still another side to the story, which is that the pieces of the sand pile that are not crystalline are actually the ones that are most able to change the sand pile into something else, like causing an avalanche, and that could be really important. We could think of that in the context of…of conceptual flexibility, which is certainly relevant for poetry. Also, in some sense, for documentaries and thinking about how a particular piece of history changes how we think about today and is generative of something at the next time point. So I think that there's something important to be said about the bits of sand pile that maintain the memory. And then there's also something important to be said for the bits of the sand pile that are dismissive of memory, in some sense, and ready to do something different.

When we think about individual humans, we sort of want both, we want this respect and care for what it is that we are carrying with us into the future, that crystalline bit, that history. We want each of us to care about that and to think about how we're doing that and whether we're doing that well. But at the same time, we want humans that are ready also to be open to a different tomorrow that is not always predicted or predetermined by our pasts. So I think we want to be multiple bits of sand at once.

We don't want to be just pickles. The way you've put it, just now, makes me think of something that is part of conserving and preserving but that we don't ever think of as structurally constituent of conserving and preserving, and that's forgetting.

Those parts of the sand pile that are mobile are doing the work of forgetting, or playing the role of forgetting and, of course, those are the ones that produce those beautiful, shifting dunes. So let me ask you, what do you think of the role of forgetting, not as in, "Oh, I forgot to go shopping," but forgetting as a part of working towards conserving.

I think for me, it's definitely a purposeful forgetting of shared narratives and a listening to independent narratives. And that seems to be really, really important for increasing the sort of diversity in the repertoire of stories that we hear.

I think it may not be too much to the point, but for me, when we do screenings, it's a weird question that comes up a lot. It's like, so what did you leave on the cutting room floor? What didn't you put in the film? And I think about it, and I always have to answer, "I don't remember, I've forgotten." Once I've cut the film, I don't think about what I didn't include in the film. And I think, partially, it's to keep my sanity. [Laughter] It would be horrible if I sat there every time I saw a film and thought, "Oh God, I should have put that in. Why didn't I put that in?" So once the film is done, the stuff is just gone. For me personally, that's kind of what I have to do. I have to forget.

LR I think I can relate to what Stanley is saying. I think part of the reason I do the work is so that I can let go of those ideas and move on to other ones. And sometimes I even find it difficult to talk about past work, because I've almost blocked it out entirely. But then you have that record, I guess. I also think about ephemeral art forms like dance or something, where the forgetting or the moving or the slipping away is built right into the art form. So there's something important in those too—that they can disappear.

PC Peter, as you frame that question, suddenly forgetting seems very beautiful. If we go back to the production, the generation-of-work side of it, rather than what happens afterwards: I wrote a long poem a few years ago about a maverick disciple of Sigmund Freud's, Victor Tausk. We don't need to go into the whole thing; he was a strange character. But Freud himself was plagued by the cryptomnesia, these hidden memories. What is this? You'd read something, but you've forgotten that you read it, or it just sort of receded in this very complicated kind of sand dune–like way that Dani's described. So it's in there somewhere, but you really genuinely don't remember having any contact with it. This happens to me all the time.

I find these things in my old notebooks and stuff, and then it comes back; you get an idea like the beginning of a poem or something, and you say, "Somebody else has had that idea

before." You don't know who, you think maybe it's plagiarism. The source of it has become completely erased, but it's in you as this kind of psychic driving force. It's a dangerous place to be in, but I find that that's where poems come from, actually—that there's a kind of experiencing and forgetting, they kind of go to sleep, and I sleep on it, they sleep on it, maybe for years, maybe for months, maybe for a couple days, whatever. But something has to be forgotten in order to be remembered, to be put together in that kind of way that a conservator or preservationist might.

I will not put on my astrophysicist hat this time, but that of a foundation president who does a lot of neuroscience. And one of the things I've learned from neuroscience work on memory is that, in some ways, we need to understand as much about the things we choose *not* to remember as about things we do. As I learned about this work, what immediately came to mind was Borges's wonderful story "Funes the Memorious." This is a tale of someone who remembers everything. He cannot distinguish, because he remembers every detail. The idea that a dog one moment and a dog one moment later were the same animal—he just couldn't do this.

As we work with neural nets for machine learning, we'll ask what the network learned. The key concept in machine learning…I think the key concept in machine learning is how we hold our memories. Generalization—how do you generalize

the class of objects that are dogs? And in order to generalize, you need to forget. Our brains are constantly choosing what is worth remembering and what is worth forgetting. Our eyes are taking in at this moment an incredible amount of data about this room, most of which we want to forget. We don't need to remember the details of how these particular lights look, or the exact pattern on the carpet. There are other things, hopefully, in this conversation that are more interesting than that. We remember a few things. What we forget and what we remember is, I think, really a central element in how our brains work.

EW I want to add one more Borges story because I feel like maybe he's the presiding deity of this conversation. And that is "The Quixote of Pierre Menard." It's this really funny account of somebody who doesn't do a translation of *Don Quixote*, but instead does a complete, absolutely word-for-word replication of it in the 20th century. And the premise of the story is how much more original this 20th-century weird text is than the original, which just uses the language of its time. So I think that, also, speaks to the way that if you try to preserve, you actually completely destroy. Replication and conservation operate in really weird ways, so that using the same word in a completely different context is going to mean something completely different. Because translation is like rebuilding in a completely different medium, not stone-for-stone but as if you have to take an original structure made of stone, and remake it, exactly the same, but in wood or clay or Lego. What will look and feel "the same" will have to be created out of entirely different structures.

Another way of thinking about forgetting is limitations. I am limited in what I can do, and I'm sure all of us here are. So, between the ideal of doing something, the ideal of finding the perfect essence of an object so that you can restore it—it's a dream, but you can try to narrate it. Or you can try to retell the story the best way you can. In a restoration you are not inventing a story, but you are telling a story, and whenever you tell a story again, and again, it changes all the time. And that's what happens. In other words, it's not that we intervene in an object and thus destroy it. No, but in the object there is also a little bit of you and me, everything. And everything you do, you do it. It's the choices that we made, but our limitation on things, at least in my case, gives me the assurance that I don't have to be so scared of things.

Forgetting seems to me like conservation in that while it is ostensibly about the past—you conserve old things; you forget things that once had been in memory and before that, had occurred—it only has meaning when placed in the context of the future. You conserve things now in order that they be around tomorrow; by forgetting the past you create a new mental landscape in the future. Sendhil had talked about valuation in terms of the different weights we assign to "present me" and "future me."

So, I'm wondering, from that angle, what's the role of the future in the part of your work that's related to conservation?

 The future, as you said, is quite central in the work of a conservation biologist. And what I do is try to bring in the perspective of the past, the deep past. A lot of people, when they think about the future of biology, get nervous because it involves scary things, like genetically modified organisms and gene editing and de-extinction and other things that I've spoken about ad nauseam.

And that is because the fear—we're back now with Jeffrey—comes from a place of believing that we've moved outside of what is natural, that people have somehow changed the rules. What I'm trying to do by giving an historical perspective is to show that it's not new that people change the rules, that we changed the rules as soon as we knew that there were rules to be changed. What we're doing now, the ability that we have now to directly change genomes through gene editing, moving genes between species, and directing evolution, is exactly what we've been doing for the last 20,000 to 30,000 years, just more efficiently. And if we want a future that is biodiverse and filled with humans, then this view that has become ecosystem-centric has to balance the human needs and the ecosystem needs. And we're going to have to embrace a technology that lets us more efficiently use the resources that we have, which really is the logical next step in our relationship with nature.

It's always been about the future. Every change that people have gone through in our relationships with other species have been because we—and we uniquely as a species—can think about the future. And we are always thinking about the future. How are we going to feed our families next year, rather than right now? How are we going to wake up to a world where we have lots of different plants, animal species, that might be aesthetically pleasing for us, or they might be really important for providing the next drug that we need to save us from whatever the next pandemic is? How do we get to that future using the

technologies of today and drawing very clearly from the past and the way that the past has progressed to the present?

When I'm thinking about the progress of science, I'm thinking about a future that unfolds on a complex landscape, like the way a river of water will fall down a mountainside, and the path the water takes is determined by the shape of the mountain. I think that if you're a conservator, you could alter the shape of the mountain and therefore alter the direction that the water is flowing. If I translate that into what happens in science, I think that if we accurately conserve the stories and the ideas and the contributions of people from marginalized identities, then we change the progression of science in the future. We alter the trajectory that water, that the flow of discovery, can take down the mountain. I think it's really important to do this preservation and restoration well, so that in the future the paths down the mountain are much more generative than they have been in the past.

I think one thing that crossed my mind in thinking about these ideas is that we've been thinking about conservation and memory in positive ways. And I think there's also a dangerous, dark side to some of these ideas. I think about even something like Make America Great Again; it's a kind of perversion of this idea of conservation. Or Putin's invasion of Ukraine as an act of restoring what may be a fantasy version of a Russian imperial past. Or if you think about originalist interpretations of the constitution that are used to perpetuate discrimination and racism. So I also want us to think about how we can counteract those backward-clinging uses of *preservation/conservation/restoration* for a future that is allowed to evolve in better ways.

EW So, what is the future? I certainly am conscious that ancient history, the study of ancient texts, classical literature, has always been an activist discipline. It's always been future-oriented. Even think about the invention of the United States, and Jefferson sort of trying to reinvent ancient constitutions to become the constitution of this country.

I'm conscious also that, ideally, I want my work to be doing things with ancient texts that are going to enable new conversations in the present and, ideally, in the future, both in the classroom for students and their teachers and for broader communities. For me, one of the most exciting things about my *Odyssey* translation project was seeing how many different poets and artists have done reinventions of it, of different pieces of that text. It's about providing new versions of both the ancient past and an ancient text that will engage a different kind of dialogue in the future.

SN So many of my films are set in the past that their future is our now. The films reflect on the present for us now, but it's the future back then. And so we're trying to make films that are set in the past, but are really important in the future, which is now, and that's what we're trying to do. And we're trying to do that without ever referring to the present. We made a film, *Freedom Riders*, a bunch of years ago, and we actually shot, like, the week after Obama was elected. And everybody that we interviewed wanted to say, "And if we hadn't done that back in 1961, Obama never would've been elected." And we constantly had to say, "Obama's not elected yet. You're back in 1961." And we learned to say that from the very moment when we sat people down. Don't refer to anything that's happening now. And, in a way, we wanted the viewer to understand that all this stuff led to now, which was

the future back in the time of the film, but without ever saying it. And that's the trick that we're trying to pull off every time: to use the past, to talk about the past's future, which is now.

PC Dani, you used the word *generative* to think about restoration. For me that word is linked to *generous*. One of the key impulses for me and my work—certainly as a translator, but I say this as a poet who thinks of poetry as a kind of deep translation—is to never lose touch with just the thrill of having certain materials from the past come through you and just completely inhabit you and possess you, and then you respond to them, you become responsible for them; the thrill and desire to pass that on to someone because you're enthusiastic about it, because you're excited, because you think it's important, because you think it will change the way they think about the present.

That's obviously a future-oriented impulse and vector. And that generosity—I think it's one of the key forces in literary transmission, and certainly in translation it's undervalued. It can be sentimentalized and all that. But when you look for the motivation behind either a lot of scholars or a lot of writers, the desire to share with at least one other person or a community is a major, major force. And so when you ask about the future, that's what I think of.

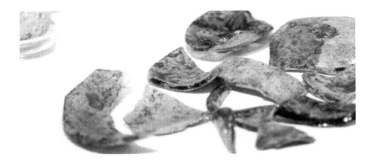

David, as someone who's worked on the cosmic microwave background radiation, and so peered 13.8 billion years into the past, you've got to have the last word about the place of the future.

 When we think of the future, it's on a very long timescale. For us, the future is hundreds of billions, or even trillions, of years, and wondering whether the universe will keep expanding forever or will eventually contract. This is a story that actually connects astronomy with poetry, because Robert Frost used to come into the Harvard Faculty Club and talk to Harlow Shapley, who was the director of the observatory there, about the possible fates of the universe. And this led to, "Some say the world will end in fire, others say in ice." And those are the two fates we think about. We don't know what makes up most of our universe. Atoms are only 5 percent of it. About 70 percent is in the form we call dark energy. These are just words we use to describe something where we simply do not understand what it is.

One of the reasons we're interested in the observations we do is to learn more about the nature of this mysterious stuff that makes up most of the universe. Until we understand its properties, we cannot really predict which path the universe will take for its future. Our current understanding is that the universe will expand forever, getting colder and colder. And we think about and talk about that future. In some ways, it is a pessimistic future, to say that things just get colder and colder, but I remember hearing the late Freeman Dyson talk about this. And Freeman pointed out that if we could get more efficient at having thoughts or conversation, and we could get more efficient at turning these conversations into making better use of our energy, and we got better at doing this fast enough, then maybe we could get more efficient faster than the universe is getting cold. Well, there are actually an infinite number of thoughts and an infinite number of conversations that lie ahead in the future.

So, let me ask, David, you presented your work in terms of "restitution," and to my ear, the account you gave of using general relativity to work back from what we can see to the distribution of matter that we can't sounded a lot like the kind of restoration work Ubaldo might do, only you're doing it with the shape of the universe, not of a sculpture.

Would earlier generations of astrophysicists and astronomers have similarly thought about what they were doing as a kind of historical or even restoration project?

 I don't know. There's a tension in the field, in that we like to think of ourselves as physicists and as scientists, but we're really historians. Physicists in most areas, or chemists, they do experiments. We don't do experiments; we observe the universe in the distorted ways we can. In very limited ways, we see things. We are given pieces of the past and we take the principles we think we understand and try to reconstruct a coherent story.

So, this is something where I've talked to some of my historian colleagues and realized that in some ways, we're more historical. We have a simpler job because physics is pretty simple, and once you understand the basic ideas, you apply it, and that's what describes things. We're trying to do a historical science, but we don't think of it that way. I think of us this way sometimes, but that's not how most of my colleagues would describe us. We like to think of ourselves as physicists for many reasons. That gets into issues of where one sits in the academy, right? What gets funded, what gets valued.

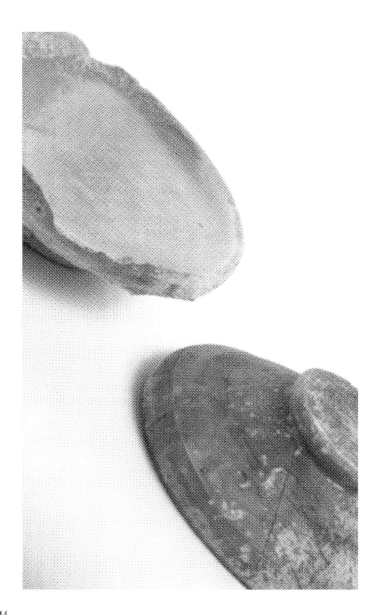

Modern conservation emerged out of the work of those who restored ancient sculpture, and that restoration involved caring for cultural heritage. In the last 50 to 75 years, the pendulum has swung very sharply against this additive approach. Conservators are now trained to do as little as possible to objects, and only to do it in such a way that it can be identified by future conservators and, potentially, reversed. But one of the intriguing things that's come out of our conversation is that the pendulum may soon start swinging back towards restoration, towards this idea, first of all, that there's always some impact that humans have when they intervene in an object's life-course, even if it's minimal. And then, second of all, that the convergence of the natural world and the human at a time of enormous change on the macro scale will push us towards a more interventionist approach. It could be very interesting to see how that happens.

 This is something actually I've been thinking about a lot, in the context of engaging in conversations in response to global warming. So, temperatures: the planet's getting hotter. We are intervening in it very significantly. One of the things we certainly want to do is decarbonize the economy, but we'll probably do that too slowly.

So, when Mount Pinatubo exploded—and volcanoes explode all the time—the planet actually got colder by a degree. Do we think about intervening? To me, this is "global climate resiliency."

But, actually, we can take some of these ideas of art conservation and scale them to the planet. Where you say, "This decay is happening," do we put up some calcium carbonate in the atmosphere, or sulfur dioxide, to increase the marine cloud cover a bit by stimulating cloud formation? There's a number of ways one could potentially do it.

We don't fully understand them or their implications, but we are affecting the planet on such a scale that I think some of these ideas of how to intervene to preserve what is valuable, the ecosystem…We may have to intervene in the decay and the problems on a global scale. Looking at the current trajectory we're on, I think we will be forced to confront global ecological issues in the 2050s.

 This geoengineering example is a great question of who gets to decide and what the different impacts are. There was a paper that came out recently that showed that the most popular of these geoengineering models would actually increase rates of malaria in most of the developing world. So, this would be people in the developed world making a decision to preserve what they're used to, and there would be enormous cost to other parts of the world. Whether they're right or not, these are all modeling approaches moving forward. But just to bring up this question, as we move toward a future, of how to do it in a way that actually values all of the stakeholders and what their futures are, in a way that is reasonable, that's equitable. We're terrible at this, as you can tell.

 Indeed. That is something we're terrible at. I think one has to be careful about the conservatism, because a lot of the conservatism comes from the wealthier Northern countries. I've engaged with people in South Africa, and particularly with people in the Caribbean, where the hurricanes are getting much worse. We in the North have much more responsibility for the carbon dioxide in the atmosphere. It's mostly our development that drove that. Then we are unwilling to even discuss the damage from CO_2. Again, it mostly affects the coastal, poor nations, the more vulnerable. So, the doing hurts them and the not doing also hurts them, the most.

Just to make one point, David, in the way you laid out the geoengineering perspective, and that is that we began the conversation with biological conservation as a way of getting at the philosophical issues in cultural heritage. With geoengineering, we're going back to viewing Earth itself as an object, to practice on it the way conservators practice on an object. So, there are convergences here that are happening.

We have to be careful which conservator is in charge.

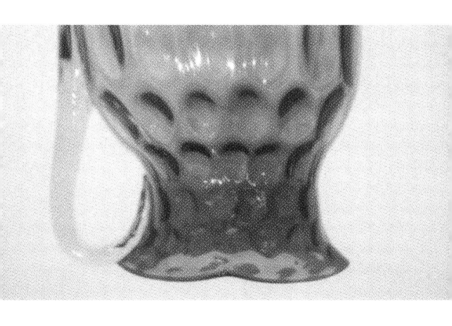

Evoking Hans Blumenberg, one of our visiting professors this semester, Lisa Regazzoni, professor of the theory of history at the University of Bielefeld in Germany, wonders if conservation is actually a marker of the beginning of modernity. She reminds us that there are philosophers who claim that the very principle of modernity, as articulated in the eighteenth century, is the replacement of God by man. This means that God is no more there to conserve and to preserve the world and the entire universe. Instead, human beings are in charge of conserving the world, things, et cetera. Conservation is thus not only identified with human action, but is identified as the preeminent way of being human.

 I love that question. I want to partly respond to it, to put out there that I've been thinking about how the texts that I spend most time with right now, *The Iliad* and *The Odyssey*, are in a way both narratives about *restoration/conservation/preservation*—and narratives about the fear of mortality and the fear of change in status as drivers towards a kind of violent restoration. The whole balance, or dialogue, between the gods and the humans we could read as an exploration of what it means for humans to be responsible for *conservation/preservation/restoration*.

Think about Odysseus coming back to Ithaca and wanting to restore his household to exactly the way it was before 20 years before. How does he perform that restoration effort? He has to do it by killing almost everybody, because the only way to restore the past is to get rid of the people who weren't there in the past, which is the suitors, and all these various other people who've been part of the time in between.

I'm also thinking about how the rage of Achilles is about a loss that cannot be restored. Agamemnon, for his part, attempts to restore a loss of honor, a loss of trust in his comrades, but finds that it can't necessarily be restored. So, just staying with these characters, we could say that it is probing the limits of restoration.

One thing I would like us maybe to hold in our minds in this conversation, no matter the discipline, is whether there are stories that inform how we think about these things, or about words that might be implicit narratives, or implicit myths in the background of our minds. These might have to do with questions about what it means to preserve one thing and lose another. Or whether or not it's possible to pay back for some kind of devastating loss.

UV Since mythology is the best explanation for everything, I think perhaps one of the things that comes to my mind is the legend of Pandora's box. It was a vase, actually. The beautiful thing about Pandora's box is that all the evil escapes, but hope hangs on underneath the rim of the vase, and that's what we're supposed to do.

The other thing that we are supposed to do, for instance as a goldsmith or an alchemist—the workshop is called laboratory; it is a place of labor and prayer. There are many things that are beyond our control. We can work at it, but we need some assistance. Either we get advice or we get help.

DS Thinking of this question, I was reminded of a talk I heard recently by Frank Wilczek. He was a leading physicist, and he codiscovered, with David Gross, our understanding of what holds nuclei together. He says, "Science is about what is, and that informs what could be. What could be, we then need to think about what should be." Religion and ethics and spirituality help guide us to what should be, and one needs to think about that triangle. I think there really are these three pieces that one needs to think about. Religion, spirituality, is essential for telling us about what should be. That's, I think, a very modern view, of course. Because if you asked someone 400 years ago, religion is also what God told them about what is. I think, for me, to become modern is to separate out those roles.

Is destruction, like Odysseus's of the suitors, somehow to be linked to restoration? With Peter Cole in the conversation I'm reminded of some kabbalistic thinking, like that of the eighteenth-century Jewish false messiah Jacob Frank recently written about by the Polish novelist Olga Tokarczuk, that saw "redemption through sin." Does this combination of Marla's buffalo and Schumpeter and Odysseus and Gershom Scholem, give us a vision of what restoration could mean, the dialectical pursuit of, or at least tolerance for, destruction to create new birth? I mean, that the perpetuation of something happens only through the buffalo or through the lightning-generated wildfires?

CM Well, this is a big question. I'll just pick up one little aspect of it. I mean, I live in Miami Beach. I'm writing about sea-level rise because there's water in the streets of Miami Beach at high tide that wasn't there 10 years ago, or 20 years ago, or 30 years ago. We're very realistically going underwater. Nobody knows if it's 20 years, 50 years, or 100 years. That is still to be determined, but it's going underwater. Yet some people say, "Won't that be great? It'll be a new Venice . . . da, da, da." That's

the kind of creative destruction model. Is that really true? I don't think so. I think it'll be kind of a malarial, uninhabitable, tropical morass, but we can believe in Venice . . . or that. We don't know yet. But it's necessary to at least believe that out of destruction positives will or can arise at some level.

The other phrase here that I'll throw into the mix, just because these phrases are interesting, is *programmed cell death*. I always find that, as an idea, it's so interesting that deep inside of life—take this only as a metaphor for now—that deep inside of life is built death, because programmed cell death allows other equivalent cells to replenish. In my own work, I feel like I have gone out of my way to build in a version of programmed cell death. I will work in an area, and I think if you look at the way a lot of academics work, they tend to stay too long. Because you work on something, and if it's successful, you become well-known for it. You're a big tree. You cast a big shadow. No other trees can grow underneath. I mean, I guess it's good for you if you want a lot of light and oxygen, but it's not great for all the other trees that could grow.

I think you see this in the research domain too—that if I move on and give up control, as you all said, the next generation of people working in that area are not going to do it the way I wanted. But, to be honest, the something different they would do would probably be better, because new minds are on it. Programmed cell death is another metaphor that I've often gone back to in my own life.

That's the same concept of having something die off, and then someone picks up the thread that you were studying and is looking at it in an entirely new light—the novel object three or whatever years later.

That seems to be the way that we do things, right? We keep reinventing, redoing each time. It must be new to us because we think it's all new. For example, regenerative agriculture. I mean, my goodness, this is how it was done in antiquity, and now it's a new thing for us. I think that's the theme I'm hearing, letting things be used…be used, then die: new ideas, new generation, regeneration, new into the future. That's what restoration is, I guess.

Campbell, you were talking about the poem you wrote about Picasso's Guernica *that's written in a 14th-century Italian style that might have come from France, and you're writing it in the 21st century. Are you a conservator or are you an innovator? Is the conservator backward facing or is the conservator looking forward?*

It's exactly correct that there's no perfect answer to that. But, I mean, in other words, it's very wise to have conserved that form, to have said, you know what, human beings did this stuff. Let's remember it and value it, even if we're not of that culture, of that time. Then maybe something new can come of us employing it in this form. I don't think my version of that form was better or different, but still, it was there: something people made, created, valued. Let's carry it forward to see what of it might be of use to us. Without looking backwards, you don't even know what…If you haven't done that, then you can't innovate, because you don't know what has already been done.

You're right that that word *innovation*, that's kind of like the future aspect of the creative destruction. We need to preserve and maybe also destroy or change, but then all of it is designed to say that tomorrow is new. There's nothing but the future, and it's coming, so it would behoove us to do it with some degree of wisdom about what has come before and be able to separate what would be useful from all the destructive stuff that we seem to be so good at.

SM I think there are two enormous changes that have happened in the last 15 or 20 years. One is very germane to this conversation, so I'll do that second. The first is the amount of written language that the average human being produces today versus 20 years ago. It's phenomenal. And it's just because we have devices where we can text and tweet. I mean, everybody is in the writing business now. Before, if you looked

outside of the narrow group of people who are in the writing business, most people did not produce much writing. Today, every person produces. But, the other thing, we've had a flourishing of conservation itself. Because everyone has phones, and with phones you've given everybody a device that can take a photo. We've all become these incredible collectors of pictures of our lives, for good or ill.

I didn't know why I was putting those mementos away, but all of us now are like, "Oh, better take a photo." It's not just of a baby. It's like, "Oh, we're here at this restaurant. Take a photo of the food. I'm about to eat." Think of how many food photographs there are. I mean, there's just an astonishing explosion. So I don't…I mean, if you asked, When did conservation hit its peak? I'd say right now. Look at how much we're conserving. And I don't know why. I can't answer the question. I can just observe the ubiquity of it. It's striking.

Collecting is full of emotion. And collecting is a kind of preservation. Does this suggest a way to bring emotions into this landscape of

CONSERVATION/ RESTORATION/ PRESERVATION?

JG I mean, I would love to ask Marla a question that I think leads to that. When you talked about burning your front lawn, or when you talked about stomping on the flora like a buffalo, can you describe that experience?

MS Exhilarating.

 Yeah, yeah. That's what I thought. And I think what's interesting is that in that action—this is me projecting, of course—you're really decentralizing the decision making from yourself. You're actually crossing into what many people would feel incredibly uncomfortable doing. And performing what could look like a crazy person, or a wild person, or somebody who's illogical. But you're doing it in support of something that impacts you, but is not you. And I think in the same way that you just described future self and past self, it is very, very much that. It's a kind of ethical conservation, the ethical preservation of thinking about and...maybe more, intentional preservation and conservation, decentralizing ourselves as the reason for thinking about the environment.

 Yes. I have no response but yes, yes, yes. It's really freeing to not have to put myself in the center of things. I live for that moment, yes. For that place.

 One thing, building on what you said, Jeffrey, about what it felt like for Marla. There is an interesting psychology literature on emotional durability, which is also related to this point about how it felt when you were stomping, and the emotion of control. The striking finding, and it's kind of obvious once you say it, though it's not obvious when you live it, is that emotions are perceived as far more durable than they actually are—far more durable, and consistently so. Like the idea that the wisdom of "this too shall pass" is deeply true. Instead, we tend to think that every emotion, when it has its grip on us, is very durable. Whatever the emotion, whether positive or negative. But we just don't appreciate that emotions are not nearly as durable as we imagine them to be, and that distorts a lot of our choices.

Is this kind of intense emotion related to the dialectic we just talked about, of "restoration through destruction"? Could it be related to thinking about the future, and specifically our own future selves? Our own very fraught, because limited, futurity?

 Yeah. I would call it seasonal. Maybe it's our "seasonality." One of the reasons I really love living in Minnesota is that we have these crazy seasons and they're extreme, every one of them, all the time. And then it will pass, and then we're going to have some other crazy or beautiful extreme weather. Yeah. All of that is rebirth, renewal. Every spring, what comes up in my front yard is different. The bees I see in the front yard, I'm seeing more and more. I'm bringing them in. If you planted, they're coming. So yes, that idea of rebirth is very, very hopeful. And I totally agree with Gary Snyder that in the future we may not be here. But I bet my front yard will be.

WORKS REFERRED TO BY THE PARTICIPANTS

Peter Cole

Cole, Peter. *Draw Me After*. New York: Farrar, Straus and Giroux, 2022.———. *The Invention of Influence*. New York: New Directions, 2014.

Hoffman, Adina, and Peter Cole. *Sacred Trash: The Lost and Found World of the Cairo Geniza*. New York: Schocken, 2011.

Saramgo, José. "To Write Is to Translate," In *The Translator's Dialogue: Giovanni Pontiero*, edited by Pilar Orero and Juan C. Sager, 85–86. Amsterdam: John Benjamins, 1997.

Campbell McGrath

McGrath, Campbell. "Guernica." In *XX: Poems for the Twentieth Century*, 76–78. New York: Ecco/Harper Collins, 2016.

Peter N. Miller

Biondo, Flavio. *De Roma instaurata libri tres* Turin, 1527 [1444–46]. https://hdl.handle.net/2027/ucm.5317949053.

Hemholtz, Hermann von. "On the Conservation of Force." Translated by Edmund Atkinson. In *Scientific Papers: Physics, Chemistry, Astronomy, Geology*. Vol. 30 of The Harvard Classics, edited by Charles W. Eliot. New York: P.

F. Collier, 1909–14. https://www.bartleby.com/30/125.html.

Kopytoff, Igor. "The Cultural Biography of Things: Commoditization as Process." In *The Social Life of Things: Commodities in Cultural Perspective*, edited by Arjun Appadurai, 64–91. New York: Cambridge University Press, 1986.

Scholem, Gershom, "Redemption through Sin." In *The Messianic Idea in Judaism and Other Essays on Jewish Spirituality*, 78–141. New York: Schocken, 1971.

Tokarczuk, Olga. *The Books of Jacob*. Translated by Jennifer Croft. New York: Riverhead, 2022.

Sendhil Mullainathan

Fullerton, Don, and Shan He. "Do Market Failures Create a 'Durability Gap' in the Circular Economy?" NBER Working Paper Series, no. 29073, National Bureau of Economic Research, Cambridge, MA, July 2021. https://www.nber.org/system/files/working_papers/w29073/w29073.pdf.

Gilbert, Daniel. *Stumbling on Happiness*. New York: Knopf, 2006.

Schumpeter, Joseph. *Capitalism, Socialism, and Democracy*. New York: Harper, 1942.

Wilson, T. D., T. Wheatley, J. M. Meyers, D. T. Gilbert, and D. Axsom. "Focalism: A Source of Durability Bias in Affective Forecasting. *Journal of Personality and Social Psychology* 78, no. 5 (2000): 821–36. https://doi.org/10.1037//0022-3514.78.5.821.

Stanley Nelson

Nelson, Stanley, and Traci Curry, dirs. *Attica*. Showtime Documentary Films/Firelight Films, 2021.
Nelson, Stanley, dir. *The Black Panthers: Vanguard of the Revolution*. Firelight Films, 2015.
———. *Freedom Riders*. Firelight Media, 2010.

Lauren Redniss

Redniss, Lauren. *Century Girl: 100 Years in the Life of Doris Eaton Travis, Last Living Star of the Ziegfeld Follies*. New York: Regan/HarperCollins, 2006.
———. *Oak Flat: A Fight for Sacred Land in the American West*. New York: Random House, 2020.
———. *Time Capsule*. New York: Make Me a World, 2022.

Beth Shapiro

Carlson, Colin J., Rita Colwell, Mohammad Sharif Hossain, et al. "Solar Geoengineering Could Redistribute Malaria Risk in Developing Countries." *Nature Communications* 13, no. 2150 (2022). https://doi.org/10.1038/s41467-022-29613-w.

David Spergel

Borges, Jorge Luis. "Funes the Memorious." In *Labyrinths: Selected Stories and Other Writings*, edited by Donald A. Yates and James E. Irby, 59–66. New York: New Directions, 2007.
Burnet, Thomas. "'God Is under Construction': The Playful Spirit of Dr. Frank Wilczek." John Templeton Foundation. 2022. https://www.templeton.org/news/god-is-under-construction-the-playful-spirit-of-dr-frank-wilczek.
Frost, Robert. "Fire and Ice." In *The Poetry of Robert Frost: The Collected Poems, Complete and Unabridged*, edited by Edward Connery Lathem, 220. New York: Henry Holt, 1969.

Ubaldo Vitali

Attar, Farid ud-Din. *The Conference of the Birds*. Translated by Afkham Darbandi and Dick Davis. New York: Penguin, 1984.
Brandi, Cesare. *Teoria del restauro*. Turin: Einaudi, 1963. In English as *Theory of Restoration*. Translated by Cynthia Rockwell. Florence: Nardini, 2005.

Emily Wilson

Borges, Jorge Luis. "Pierre Menard, Author of the *Quixote*." In *Labyrinths: Selected Stories and Other Writings*, edited by Donald A. Yates and James E. Irby, 36–44. New York: New Directions, 2007.
Wilson, Emily, trans. *The Odyssey*. By Homer. New York: W. W. Norton, 2018.

BIOS

Marla Spivak is a MacArthur Fellow and McKnight Distinguished Professor in Entomology at the University of Minnesota. Her research efforts focus on protecting and enhancing the health of honey bees, and on propagating floral rich landscapes to support all pollinators.

Dani S. Bassett (they/them) is the J. Peter Skirkanich Professor at the University of Pennsylvania, with appointments in the Departments of Bioengineering, Electrical & Systems Engineering, Physics & Astronomy, Neurology, and Psychiatry. Bassett is also an external professor of the Santa Fe Institute. Bassett is most well-known for blending neural and systems engineering to identify fundamental mechanisms of cognition and disease in human brain networks. Bassett just completed a book for MIT Press entitled Curious Minds: The Power of Connection (2022), with co-author Perry Zurn, Professor of Philosophy at American University. Bassett received a B.S. in physics from Penn State University and a Ph.D. in physics from the University of Cambridge, UK as a Churchill Scholar, and as an NIH Health Sciences Scholar. Following a postdoctoral position at UC Santa Barbara, Bassett was a Junior Research Fellow at the Sage Center for the Study of the Mind. Bassett has received multiple prestigious awards, including American Psychological Association's 'Rising Star' (2012), Alfred P Sloan Research Fellow (2014), MacArthur Fellow Genius Grant (2014), Early Academic Achievement Award from the IEEE Engineering in Medicine and Biology Society (2015), Harvard Higher Education Leader (2015), Office of Naval Research

Young Investigator (2015), National Science Foundation CAREER (2016), Popular Science Brilliant 10 (2016), Lagrange Prize in Complex Systems Science (2017), Erdos-Renyi Prize in Network Science (2018), OHBM Young Investigator Award (2020), AIMBE College of Fellows (2020), American Physical Society Fellow (2021). Bassett is the author of more than 400 peer-reviewed publications, which have garnered over 42,000 citations, as well as numerous book chapters and teaching materials. Bassett is the founding director of the Penn Network Visualization Program, a combined undergraduate art internship and K-12 outreach program bridging network science and the visual arts. Bassett's work has been supported by the National Science Foundation, the National Institutes of Health, the Army Research Office, the Army Research Laboratory, the Office of Naval Research, the Department of Defense, the Alfred P Sloan Foundation, the John D and Catherine T MacArthur Foundation, the Paul Allen Foundation, the ISI Foundation, and the Center for Curiosity.

Peter Cole's most recent collection of poems is Draw Me After (FSG). His many volumes of translation from medieval and modern Hebrew and Arabic include *The Dream of the Poem: Hebrew Poetry from Muslim and Christian Spain*, 950–1492. Cole has received numerous honors for his work, including an American Academy of Arts and Letters Award in Literature, a Guggenheim Foundation Fellowship, and a National Jewish Book Award for Poetry. He was a 2007 MacArthur Fellow.

Jeffrey Gibson is an interdisciplinary artist based in Hudson, NY. His artworks make reference to various aesthetic and material histories rooted in Indigenous cultures of the Americas, and in modern and contemporary subcultures. Gibson's solo exhibitions include, When Fire Is Applied To A Stone It Cracks (2019), The Brooklyn Museum; The Anthropophagic Effect (2019), The New Museum, New York; Jeffrey Gibson, LIKE A HAMMER (2018), organized by the Denver Art Museum; This Is The Day (2018), organized by The Wellin Museum; Look How Far We've Come! (2017), Haggerty Museum of Art, Milwaukee; Jeffrey Gibson: Speak to Me, (2017), Oklahoma Contemporary Arts Center, Oklahoma City; A Kind of Confession (2016), Savannah College of Art and Design Museum, Savannah. Select group exhibitions include, The 2019 Whitney Biennial, Whitney Museum, NYC; Aftereffect (2019), Museum of Contemporary Art, Denver; Suffering from Realness (2019), Massachusetts Museum of Contemporary Art, North Adams, MA; Art for a New Understanding: Native Voices, 1950s to Now (2018), Crystal Bridges, Bentonville, AR. Gibson's work is included in the permanent collections of the Whitney Museum of American Art; Brooklyn Museum of Art; Denver Art Museum; Museum of Fine Arts, Boston; Smithsonian Institution's National Museum of the American Indian, Washington D.C.; National Gallery of Canada in Ottawa; Crystal Bridges Museum of American Art, Bentonville, AR; among many others. Gibson is a recipient of numerous awards, notably a MacArthur Foundation Fellowship (2019); Joan Mitchell Foundation, Painters and Sculptors Award (2015); and Creative Capital Foundation Grant (2005).

Campbell McGrath is the author of eleven books of poetry, including *Spring Comes to Chicago*, *Seven Notebooks*, *XX: Poems for the Twentieth Century*, a Finalist for the 2017 Pulitzer Prize, and most recently *Nouns & Verbs: New and Selected Poems* (Ecco Press, 2019). He has received numerous literary prizes for his work, including the Kingsley Tufts Award, a Guggenheim Fellowship, a MacArthur Fellowship, a USA Knight Fellowship, and a Witter-Bynner Fellowship from the Library of Congress. His poetry has appeared in the *New Yorker*, *Harper's*, *Atlantic* and on the op-ed page of the *New York Times*, as well as in scores of literary reviews and quarterlies. Born in Chicago, he lives with his family in Miami Beach and teaches at Florida International University, where he is the Philip and Patricia Frost Professor of Creative Writing and a Distinguished University Professor of English.

Peter N. Miller is Dean and Professor of Cultural History at the Bard Graduate Center in New York City. He is the author of a series of books on the early seventeenth-century antiquarian, Nicolas Fabri de Peiresc, on the history of antiquarianism in Europe, and on the modern study of objects as evidence. He co-curated Dutch New York Between East and West: The World of Margarieta van Varick (BGC, 2009), What Is the Object? (BGC, 2022) and Conserving Active Matter (BGC, 2022), the exhibition and website that concluded the ten-year long project he directed, "Cultures of Conservation," funded by the Andrew W. Mellon Foundation. His main current interest is in the how and why of research, whether done by professional historians or by curators, conservators or artists. He has been at Bard since 2001. He previously taught at the University of Cambridge, University of Chicago and University of Maryland, College Park. He was a research fellow at the Warburg Institute, University of London, the

Wissenschaftskolleg zu Berlin/ Institute for Advanced Study, and visiting professor at the École des Hautes Études en Sciences Sociales in Marseille and École Normale Supérieure in Paris. He has been the recipient of fellowships from the National Endowment for the Humanities, the John Simon Guggenheim Foundation, and the John D. and Catherine T. MacArthur Foundation.

Sendhil Mullainathan is the Roman Family University Professor of Computation and Behavioral Science at Chicago Booth, where he is also the inaugural Faculty Director of the Center for Applied Artificial Intelligence. His current research uses machine learning to understand complex problems in human behavior, social policy, and especially medicine, where computational techniques have the potential to uncover biomedical insights from large-scale health data. He recently co-authored *Scarcity: Why Having too Little Means so Much* and writes regularly for the *New York Times*. Additionally, his research has appeared in a variety of publications including the *Quarterly Journal of Economics*, *Science*, *American Economic Review*, *Psychological Science*, the *British Medical Journal*, and *Management Science*. Mullainathan helped co-found a non-profit to apply behavioral science (ideas42), co-founded a center to promote the use of randomized control trials in development (the Abdul Latif Jameel Poverty Action Lab), serves on the board of the MacArthur Foundation, has worked in government in various roles, is affiliated with the NBER and BREAD, and is a member of the American Academy of Arts and Sciences. Prior to joining Booth, Mullainathan was the Robert C. Waggoner Professor of Economics in the Faculty of Arts and Sciences at Harvard University, where he taught courses about machine learning and big data. He began his academic career at the Massachusetts Institute of Technology.

Mullainathan is a recipient of the MacArthur "Genius Grant," has been designated a "Young Global Leader" by the World Economic Forum, was labeled a "Top 100 Thinker" by *Foreign Policy Magazine*, and was named to the "Smart List: 50 people who will change the world" by *Wired Magazine* (UK). His hobbies include basketball, board games, googling, and fixing up classic espresso machines.

Stanley Nelson is today's leading documentarian of the African-American experience. His films combine compelling narratives with rich historical detail to illuminate the underexplored American past. A MacArthur "Genius" Fellow, Nelson has received nearly every award in broadcasting, including five Primetime Emmy Awards, and lifetime achievement awards from the Emmys, the Peabody Awards, and the International Documentary Association. In 2013, Nelson was honored with the National Medal in the Humanities from President Barack Obama. His latest documentary film is *Attica*, with Traci A. Curry, on the 1971 prison uprising, which premiered as the opening night documentary at the 2021 Toronto International Film Festival, is shortlisted for the 94th annual Academy Awards, and is now streaming on Showtime. Other recent films include the Emmy-nominated *Tulsa Burning: The 1921 Race Massacre*, with Marco Williams, for the History Channel; *Crack: Cocaine, Corruption & Conspiracy*, for Netflix; and *Miles Davis: Birth of the Cool*, which became Nelson's 10th Sundance Film Festival premiere and first Grammy nomination for Best Music Film in 2020. Mr. Nelson's film *The Black Panthers: Vanguard of the Revolution* (2016), is the first comprehensive feature length historical documentary portrait of that iconic organization, as well as a timely look at an earlier phase of Black activism around police violence in African American communities. The film won the 2016 NAACP Image Award.

Nelson's two previous films, *Freedom Riders* (2010, three Primetime Emmy Awards and included in the National Film Registry by the Library of Congress) and *Freedom Summer* (2014, Peabody Award), took a fresh look at multiracial efforts to register Black voters and desegregate public transportation facilities in the Jim Crow South, critical events in the civil rights struggles of the 1960s. Nelson's 2003 film The Murder of Emmett Till, about the brutal killing of a fourteen-year-old African American boy in Mississippi in 1955, an event that had a galvanizing effect on the mid-century civil rights movement, uncovered new eyewitnesses to the crime and helped prompt the U.S. Department of Justice to reopen the case. In 2000, Mr. Nelson, along with his wife, Marcia A. Smith, founded Firelight Media, a non-profit organization that supports and develops nonfiction filmmakers of color, and Firelight Films, a production company that produces nonfiction films by and about communities of color.

Lauren Redniss is an author, artist, and the recipient of a MacArthur Foundation Fellowship. Her book *Thunder & Lightning: Weather Past, Present, Future* won the 2016 PEN/E.O. Wilson Literary Science Writing Award. *Radioactive: Marie & Pierre Curie, A Tale of Love and Fallout* was a finalist for the National Book Award. Her most recent book is *Oak Flat: A Fight for Sacred Land in the American West* (2020). She has been a Guggenheim fellow, a fellow at the New York Public Library's Cullman Center for Scholars & Writers and the New America Foundation. She was Artist-in-Residence at the American Museum of Natural History in 2013 and, in 2020, New York City Ballet's featured visual artist at Lincoln Center. She teaches at the Parsons School of Design in New York City.

Beth Shapiro is an evolutionary biologist who specializes in the genetics of ice age animals and plants. A pioneer in the scientific field called "ancient DNA," Beth travels extensively in the Arctic regions of Alaska, Siberia, and Canada collecting bones and other remains of long-dead creatures including mammoths, giant bears, and extinct camels and horses. Using DNA sequences extracted from these remains, she hopes to better understand how the distribution and abundance of species changed in response to major climate changes in the past, and why some species go extinct while others persist. The results could be used to help develop strategies for the conservation of species that are under threat from climate change today. As Professor and co-director of the Paleogenomics Laboratory at the University of California Santa Cruz and an Investigator with the Howard Hughes Medical Institute, Beth also develops techniques to recover and analyze increasingly trace amounts of DNA, such as from environmental and forensic samples and uses these data to discover how biological communities and ecosystems might be made more resilient. Beth is highly acclaimed for her research; she has been named a Searle Scholar, Packard Fellow, National Geographic Explorer, and MacArthur Fellow. She is also an award-winning popular science author and communicator who uses her research as a platform to explore the potential of genomic technologies for conservation and medicine. Her widely acclaimed books "How to Clone a Mammoth: The Science of De-extinction" (Princeton University Press 2015) and "Life As We Made It" (Basic Books 2020) explore how humans have been manipulating life on Earth for as long as we have existed, as well as the possibility of and justification for extending this manipulation to bring extinct species back to life.

David N. Spergel is the President of the Simons Foundation. He is the Charles Young Professor of Astronomy Emeritus at Princeton University and was the Founding Director of the Center of Computational Astrophysics at the Flatiron Institute in NY. Spergel received his undergraduate degree from Princeton in 1982 (summa cum laude, Phi Beta Kappa). After a year of study at Oxford University, he received his PhD from Harvard in 1985. After two years as a long-term member at the Institute for Advanced Study, he joined the Princeton astrophysics faculty in 1987, where he was also Associate Faculty in the Departments of Physics and Mechanical and Aerospace Engineering. He served as Department Chair from 2006 to 2016. During his term as chair, the department was consistently ranked as #1 by US News and World Report and by the NAS. In 2016, he became the Founding Director of the Center for Computational Astrophysics. In 2021, he assumed leadership of the Simons Foundation. Spergel is the author of over 400 papers with over 115,000 citations and an h index of 127.

Emily Wilson is a Professor in the Department of Classical Studies and Chair of the Program in Comparative Literature and Literary Theory at the University of Pennsylvania and is the College for Women Class of 1963 term professor in the Humanities. Her books include *Mocked with Death: Tragic Overliving from Sophocles to Milton* (Johns Hopkins 2005), *The Death of Socrates: Hero, Villain, Chatterbox, Saint* (Harvard 2007), and *The Greatest Empire: A Life of Seneca* (Oxford 2014). She is the Classics editor of the revised Norton Anthology of World Literature. Her verse translations include *Six Tragedies of Seneca* (Oxford), four translations of plays by Euripides in the Modern Library *The Greek Plays* (2016),

Oedipus Tyrannos (2020 Norton), and the *Odyssey* (2017, with a Norton Critical Edition published in 2020). She is working on a new translation of the *Iliad*, which is due to appear in 2023. She edited a volume on Ancient Tragedy for Bloomsbury Cultural Histories (2019). She was named a MacArthur Fellow in 2019, and won a Guggenheim Fellowship in 2020.

Ubaldo Vitali was born in Rome 1944 into a fourth generation family of silversmiths. He studied at Liceo Artistico, Rome; L'Accademia di Belle Arti, Faculty of Sculpture, Rome; L'Universitá di Roma, Faculty of Architecture, Rome. He has conserved and restored works of art for the Soprintendenza alle Belle Arti (the institution overseeing Italian museums), as well for various European museums and galleries. He has also designed and executed silver objects for the Italian government as gifts to foreign dignitaries, as well as three popes, the Queen of England, and the Shah of Iran. He moved to the United States in 1967. He has since worked for leading American museums, such as The Metropolitan Museum of Art, The Detroit Institute of Art, The Toledo Museum of Art, The Boston Museum of Fine Arts, Yale Art Gallery, North Carolina Museum, The Newark Museum, The Dallas Museum, and many others. He has been commissioned by the US State Department to design and execute silver objects to be given to foreign dignitaries by the President of the United States as presidential gifts. His objects are in the permanent collections of The Newark Museum, the Houston Museum, the Yale Art Gallery, and the Smithsonian American Art Museum Renwick Gallery. His works have been exhibited in the Metropolitan Museum of Art in New York, the Minneapolis Institute of Art, as well as a solo exhibition in the Newark Museum, Oct–Dec 1990.